CASTLE DOUGLAS

THROUGH TIME

Mary Smith & Allan Devlin

AMBERLEY

First published 2017

Amberley Publishing
The Hill, Stroud, Gloucestershire, GL5 4EP
www.amberley-books.com

Copyright © Mary Smith & Allan Devlin, 2017

The right of Mary Smith & Allan Devlin to be identified
as the Authors of this work has been asserted in
accordance with the Copyrights, Designs and Patents
Act 1988.

ISBN 978 1 4456 5969 5 (print)
ISBN 978 1 4456 5970 1 (ebook)

British Library Cataloguing in Publication Data.
A catalogue record for this book is available from the
British Library.

Origination by Amberley Publishing.
Printed in Great Britain.

Introduction

The market town of Castle Douglas, in Dumfries and Galloway, south-west Scotland, sits beside beautiful, island-studded Carlingwark Loch with its popular caravan park, boating and other water-sports facilities.

The area has been populated since ancient times. Dugout canoes have been found in Carlingwark Loch and traces of prehistoric crannogs can still be seen. A bronze cauldron was discovered in the 1860s, which has been dated at between AD 80 and AD 200. It is likely the cauldron was used for feasts by the tribal chief before being filled with tools, craftwork and weapons and thrown into the loch as an offering to the gods. At nearby Glenlochar, evidence of two Roman camps have been found.

Castle Douglas itself, however, is relatively modern and its development is down to the vision of one man. Not many men born to such a lowly situation in life – he started out as a packman or pedlar – can rise to a position from which to buy up estates, both here and further west, and build two towns named after himself. Yet that is what William Douglas, later Sir William, achieved.

Born in 1745, William followed some of his brothers to America where he amassed a fortune through unspecified trade in Virginia. It is said he owned plantations, and was perhaps also involved in privateering. On returning to his homeland he bought an estate in the west of the region, developed a town called Newton Douglas (now, Newton Stewart), and then bought further land, which included the village of Carlingwark, from the Gordon family.

Alexander Gordon of Culvennan, discovering the loch contained deposits of marl, which could be used as a fertilizer, partly drained it and built a canal from the loch to the River Dee. Workers came to dig out the marl and transport it to farms along the Dee and up Loch Ken to the Glenkens. Causewayend, a hamlet beside the loch, grew to a population of 700 people.

Unfortunately, too much marl on the land proved to be counterproductive, and a further blow to the Gordon family was the collapse of the Bank of Ayr, in which Alexander Gordon was a co-partner. In 1791, William Douglas helped solve some of the family's financial problems by buying land for the sum of £14,000.

Douglas chose the site of his town shrewdly as it was already strategically placed on a main road network including the Old Military Road, built to allow the rapid movement of troops, which joined the main thoroughfare. The town was grid-planned with three

parallel main streets: King Street in the centre with Queen Street and Cotton Street to either side, intersected by other streets. He named it Castle Douglas – he was not a modest man – and proceeded to build himself a 'castle' near Gelston.

However, his attempt to establish a cotton-spinning industry failed. Lacking water power for production and canal transport for raw materials and finished products, Castle Douglas could not compete with industrialised cotton spinning established elsewhere. Despite this setback, the town thrived and prospered. Sir William would have been pleased to read the words of the historian, Heron, on Castle Douglas: 'This village every day becomes more thriving and more respectable; flax-dressers, weavers, tanners, saddlers, cotton-spinners, masons and carpenters are now established here' – all this even before the advent of the cattle market and the railway.

Situated in the heart of rich agricultural lands, Castle Douglas is an important and thriving market town. Wallets Marts has been marketing livestock since 1856 and have occupied their present 10-acre site since 1888. The opening of the railway in 1859 brought further prosperity to the town.

Threave Castle was built in the fourteenth century for Archibald, who became the 3rd Earl of Douglas – a hugely powerful family. So powerful, in fact, James II decided to take action against the Black Douglas and the castle was under siege for three months. Later, during the Napoleonic Wars, it was used for French prisoners of war.

Castle Douglas has a well-deserved reputation as a shoppers' paradise with a range of independent, speciality shops selling everything from fashion through furniture, to unique gifts. It holds the title of the region's food town with many of the shops and businesses selling locally produced food and drink. Family-owned butcher shops, bakers, greengrocers and fishmongers are to be found on King Street, the town's main shopping street, and it has its own award-winning brewery.

The town is an ideal centre from which to explore the surrounding countryside with its many picturesque Galloway villages. The photographs show some aspects of why Castle Douglas is such a special town.

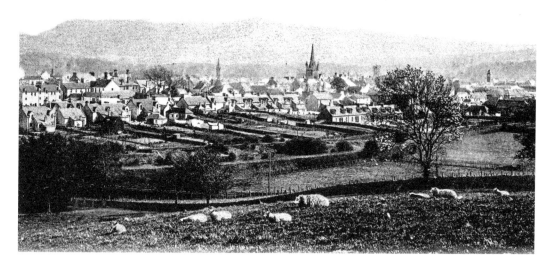

Castle Douglas from Dunmuir Hill

The imposing spire of St George's Free Church dominates the old picture of the town. The square white building in the centre is the telephone exchange. Houses have now been built where the railway line used to run and a green space was created, called Burghfield Park. The hills in the background are Screel and Bengairn.

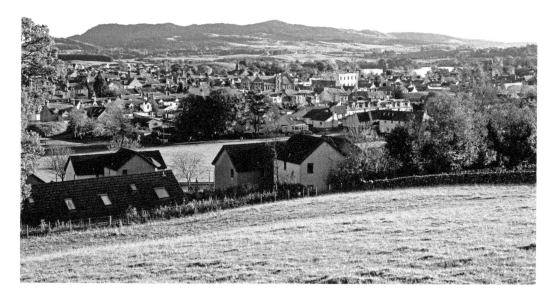

CLOCK TOWER, CASTLE DOUGLAS

Town Clock Tower, King Street and St Andrew Street

Sir William Douglas built the first clock tower and town house, which was destroyed by fire in 1892. Forty years later, a second one suffered the same fate. A bronze plaque on the wall states the clock in this third tower was gifted in 1935 by Henry J. Hewat of Paterson, New Jersey, USA and Castle Douglas. A flat is above the ground-floor shops, which have their original plate-glass fronts. The St Andrew Street shop in the old photo was R. S. McColl.

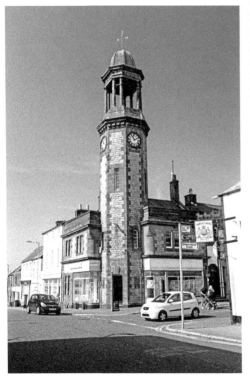

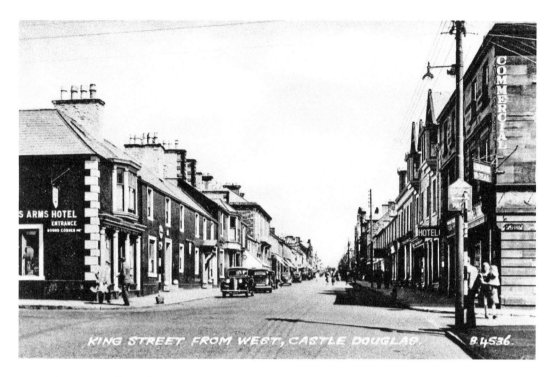

King Street, from the West

The Douglas Arms Hotel, on the left, now takes up the entire frontage to the corner. In the earlier photo there is a grocer's shop in the corner portion of the building. The Commercial Hotel on the right offered 'Luncheons and Teas'. The town was already busy in the 1950s but the volume of traffic has grown enormously. One feature missing in the recent photo is the telegraph wires and poles running up, down and across the street.

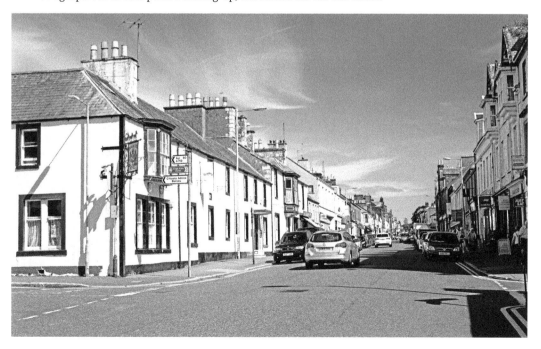

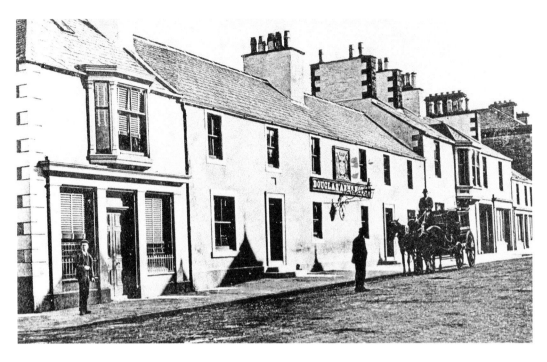

Douglas Arms Hotel, King Street

Built in 1772 or 1779, the hotel is a former coaching inn. Later it extended to take in the premises below and round the corner on St Andrew Street. The town's founder, Sir William Douglas, possibly stayed here before building his castle at Gelston. Set in the wall is a milestone, cast in Dumfries in 1827, giving the mileage to Dumfries, Glasgow, Edinburgh, Carlisle and London. A former provost, Dr Donald, rescued it from a ditch.

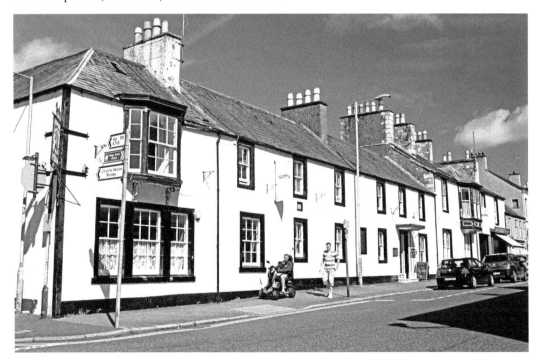

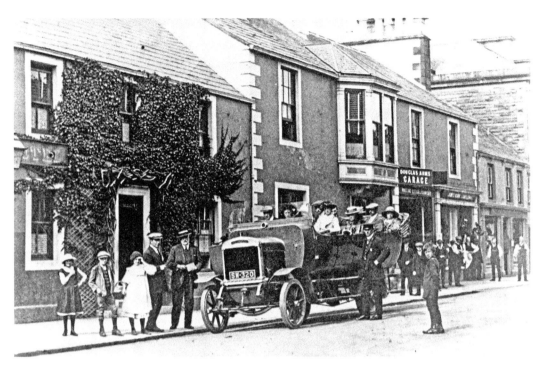

Douglas Arms Hotel, King Street

The Payne family owned the hotel for eighty-three years. A 1908 advert gives the address for telegrams as 'Payne, Castle Douglas' and offers to send a bus to meet all trains. Perhaps these hotel guests are about to go out for a tour of the countryside in the charabanc. Its presence is certainly receiving much interest from bystanders.

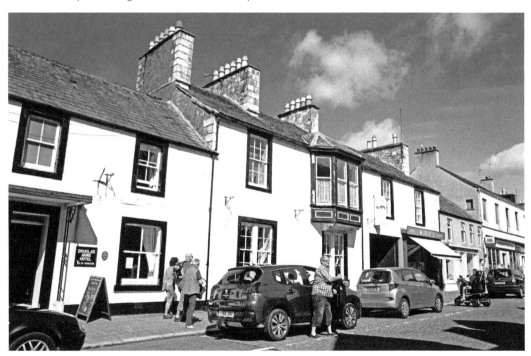

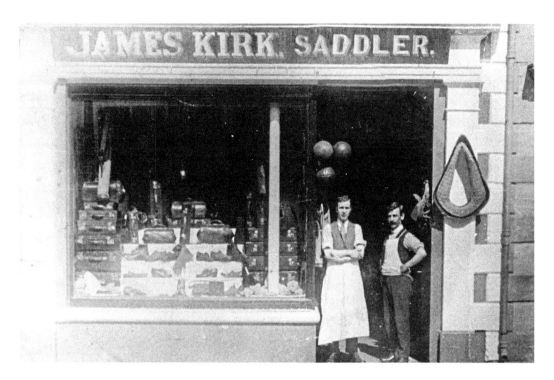

James Kirk, King Street

The shop was established in the late nineteenth century by master saddler James Kirk. For the next half-century, saddlery was the main trade until cars replaced horses and the business diversified to focus on footwear and outdoor clothing. Billy Kirk, standing outside his shop with Janet Chisholm, is the third generation of Kirks.

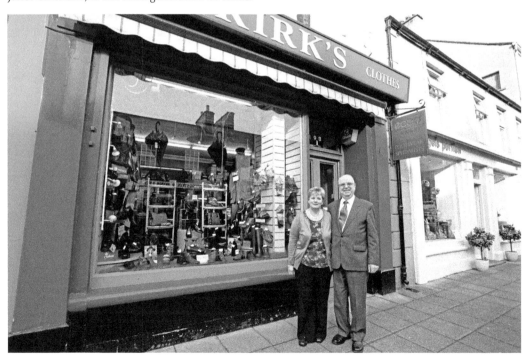

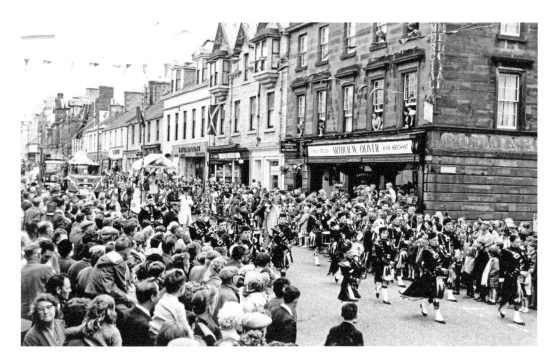

King Street, Douglas Day Parade

Civic Week is a week-long series of events in July that culminates in the parade on Douglas Day. Pipe bands are still a feature, though today's bands are less formally attired. In the old photo, the parade has reached the corner of King Street and St Andrew Street. Oliver's family grocer and wine merchant is now a Chinese restaurant. Above, what was originally a private residence became the Commercial Hotel, then the Merrick Private Hotel and is now an Indian restaurant.

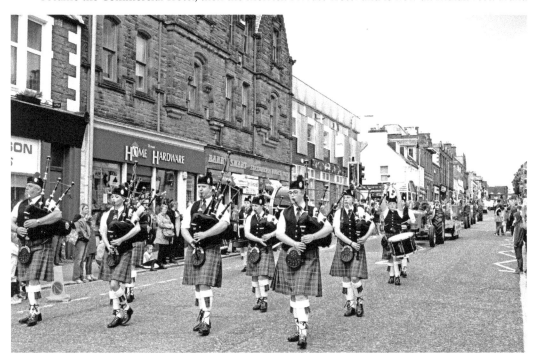

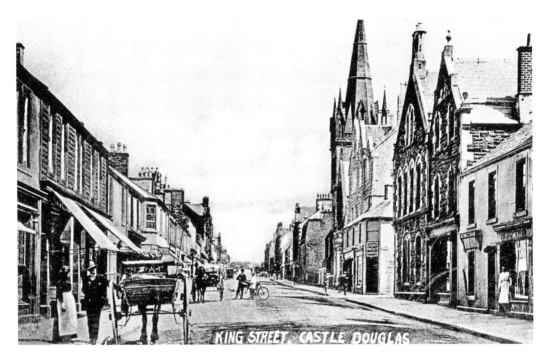

King Street

St George's Free Church, with its tall spire, is on the right of the old picture. In 1923, it amalgamated with the church on Queen Street. A Mr Dalling opened an antique shop in St George's, which became known as Dalling's Kirk. The spire, considered unsafe, was removed. Since then, this right-hand section of King Street has seen many structural changes, although the Royal Bank of Scotland, built in 1864 with granite from Craignair near Dalbeattie, remains an imposing building.

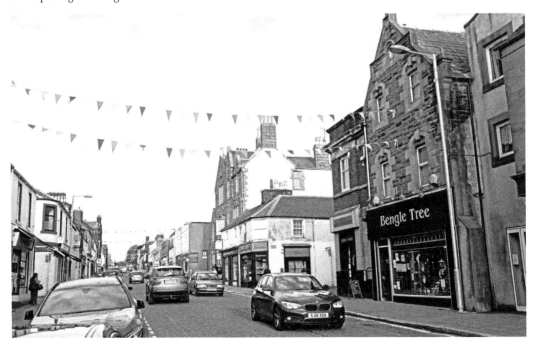

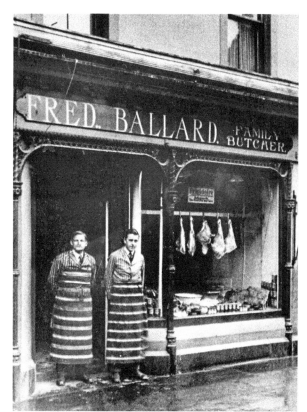

Fred. Ballard, King Street
Visitors to the town are often surprised to find Castle Douglas has three family-run butchers on King Street. Long established, Fred. Ballard is one of them. The shop was first opened in 1879 and, although thoroughly modern inside, its frontage resembles the original one. Standing outside the shop today is Jimmy Craig and Senga Baird. The old photo shows Fred Ballard Snr and Davey Kelly, a weel-kent figure in the town and surrounding farms.

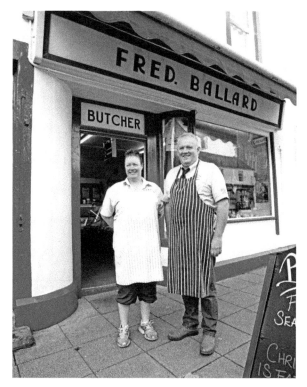

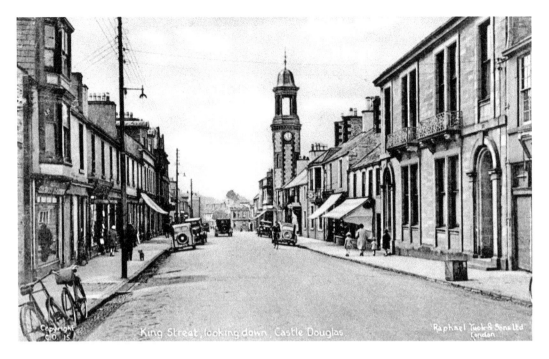

King Street, Looking Down Towards the Clock Tower

King Street is the town's main street and is always busy. Parking was a lot easier in the 1950s than it is today. The modernised Bank of Scotland has little of the character of the previous building with its wrought-iron balconies and imposing entrance. The first branch of the Bank of Scotland opened in 1840 across the road on the corner of King Street and Church Street. The Bank of Scotland pictured here was originally the British Linen Bank.

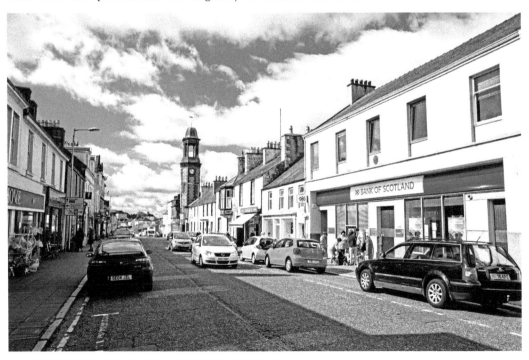

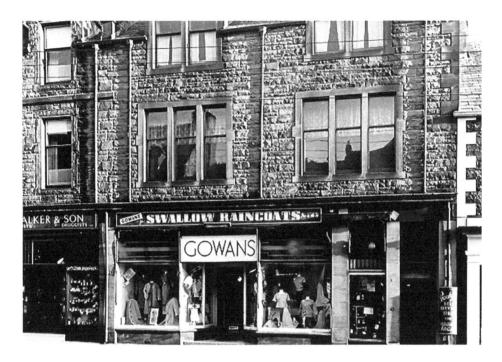

Gowans, King Street

The business started in the late 1800s when 'tailor and cutter' James Gowans began trading in Dalbeattie. He specialised in frock coats and tails for men and bustle skirts and wasp waists for ladies. His son George travelled around the Stewartry in his 1903 De Dion motor car selling from his sample ranges. When his son James joined the business, the move to Castle Douglas was made. The head office and main shop has been at Nos 81–83 King Street for over sixty years.

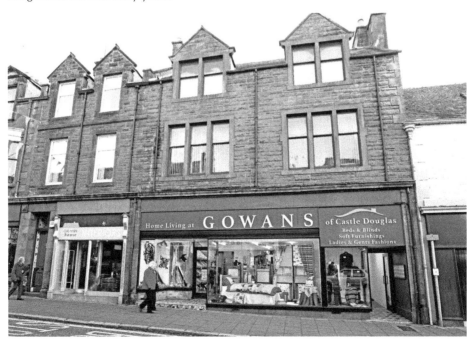

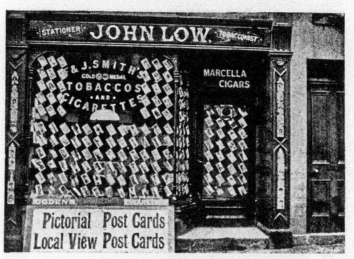

To enjoy
your visit
Smoke
LOW'S

"THREAVE"
MIXTURE.

5d. per oz.

A Perfect
Smoke.

Cigars,
Cigarettes,
Tobaccos,
Pipes,
Pouches, etc.

Your friends
will enjoy
your visit if
you send
them LOW'S
"Galloway"
Series of
PICTORIAL
POST-CARDS

Newspapers,
Periodicals,
Magazines,
Fountain
Pens,
Stationery,
Walking
Sticks.

JOHN LOW, *Bookseller, Stationer & Tobacconist,* Castle Douglas.

Solicitors Property Centre, King Street

The door on the right of the old image is now the smaller of the windows of the Solicitors Property Centre. John Low opened his shop here in 1900. He was a bookseller, stationer, newsagent and tobacconist. He also published his own picture postcards called the Galloway series, several of which are included in this book. In 1925, he moved into the much larger shop next door and successive generations continued the business until Drew Low retired in 2010.

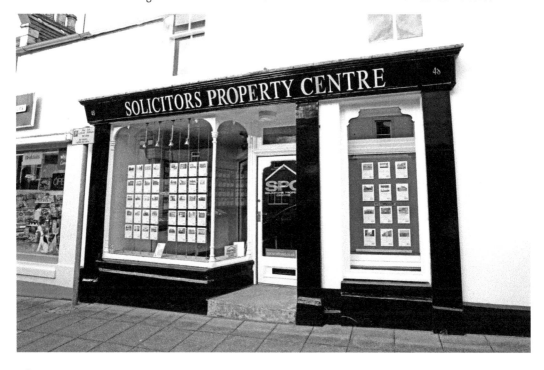

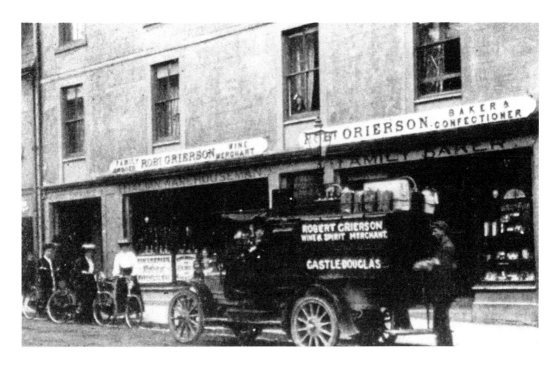

Robert Grierson, King Street

In an advert in Maxwell's 1908 guide to the Stewartry, this family grocer, which was also a wine and spirit merchant, family baker and confectioner, promised prompt attention to orders by post or telegram. The female cyclists – how did they manage in those skirts? – are standing by the goods entrance. Later, this was Stevenson's, also a grocer and bakers, now replaced by Sunrise Wholefoods and the Mad Hatter Café.

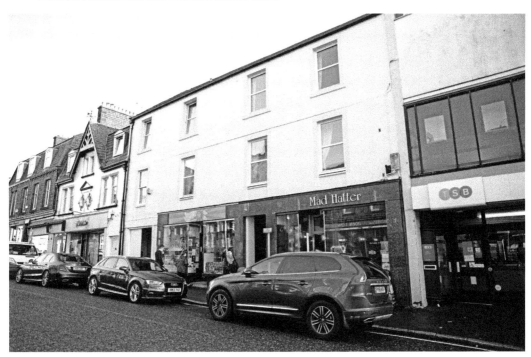

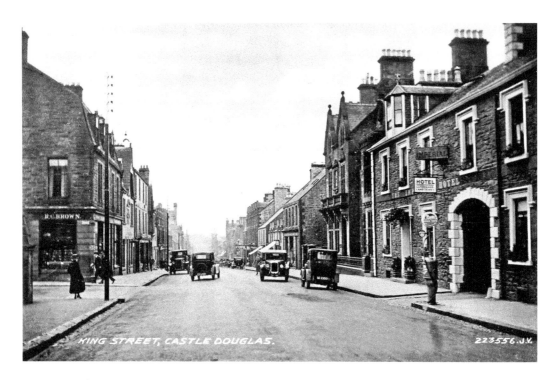

The Imperial Hotel, King Street

The hotel, formerly called the Globe Inn, was built around 1820. It was a coaching inn with the archway leading into a courtyard where horses would be changed on long journeys. It was bought by Samuel Solley in 1920 and remained in family ownership for almost a century. By the time the photo was taken, the horse had been superseded by the motor car as evidenced by the traffic on the road and the single petrol pump outside the hotel.

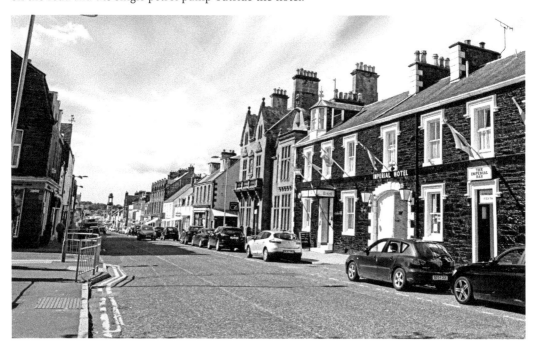

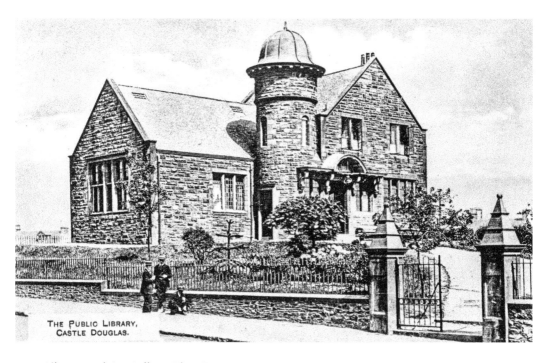

THE PUBLIC LIBRARY,
CASTLE DOUGLAS.

Library and Art Gallery, King Street

The Scottish-American industrialist Andrew Carnegie provided a donation of about £2,800 to build the library, designed by architect George Washington Browne. It opened in 1904. The old photograph shows there was originally a round-arched pediment-style canopy over the door. A flat above the library was provided for the librarian. In 1938, artist Ethel S. G. Bristowe provided for the addition of the art gallery and donated some of her works. The monkey puzzle tree was planted around 1920.

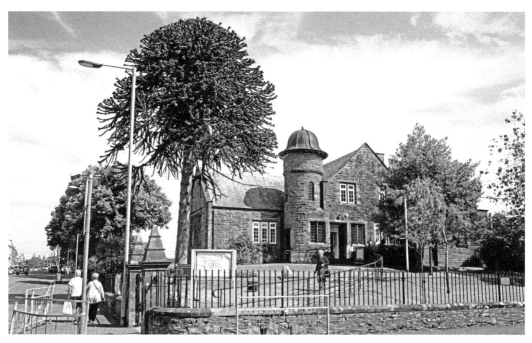

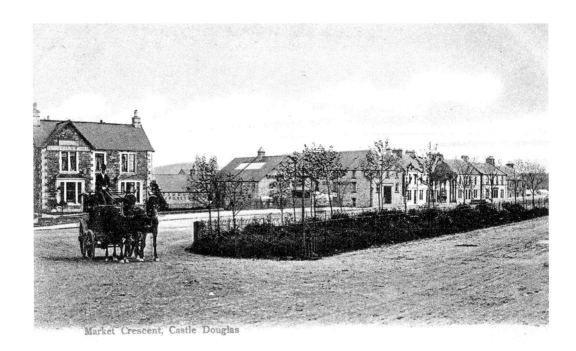

Market Crescent, Castle Douglas

Market Crescent

The Temperance Hotel in the old image became the Station Hotel. The space beside it is now occupied by County Tyres. The seed merchant's building in the old picture is now a West Cumberland Farmers (WCF) store selling pet and equestrian supplies. The fountain can be seen opposite what is now The Market Inn, which dates the image to around 1897.

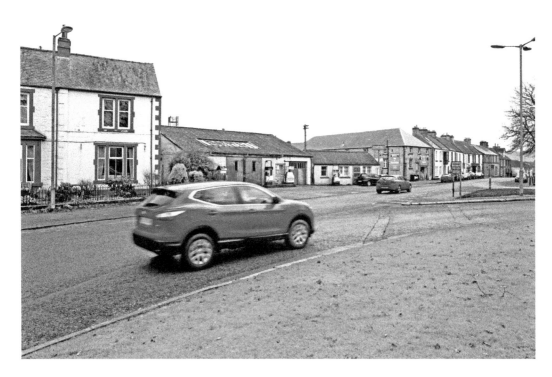

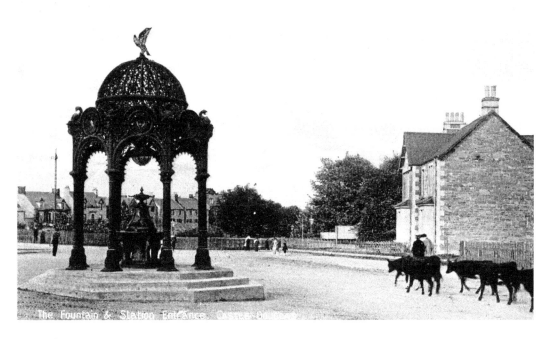

The Fountain & Station Entrance, [illegible]

The Fountain, Station Square

The fabulous, ornate fountain was erected in honour of Queen Victoria's Diamond Jubilee in 1897. It has long gone, removed during the Second World War when scrap metal was vitally needed. The traffic island where it once stood always has bright flower beds in summer. It appears the cattle are heading for the station, probably from the nearby market. Behind where people are at the station entrance is now Tesco supermarket. The Station Hotel on the right was once a temperance hotel.

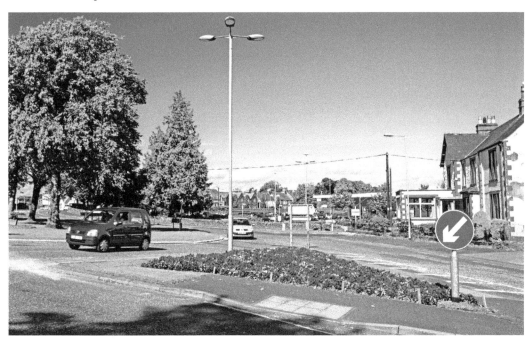

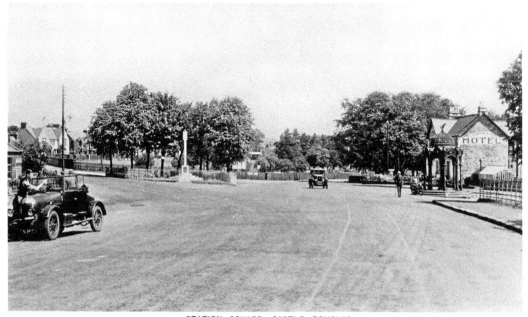

STATION SQUARE, CASTLE DOUGLAS.

Station Square

Station Square was chosen in 1921 as the site of the elegant, white-granite war memorial, topped with the town's coat of arms. The town's main streets converged here and met traffic coming to and from Dumfries and Dalbeattie. The few vehicles had plenty of room but a roundabout is now necessary to ensure the smooth flow of traffic – and the war memorial is on a traffic island. A motorcycle is parked beside the fountain near the Station Hotel.

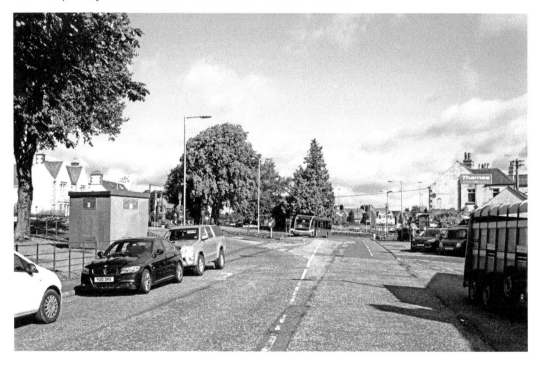

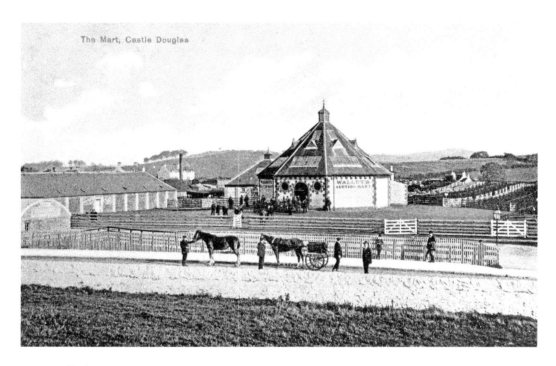

Wallet's Mart

Around 1856, Thomas Wallett sold a few Galloway cattle and some sheep on open ground at the Market Hill. Joined by his brother, the business flourished, becoming the premier livestock sales centre in south-west Scotland. By 1888 the octagonal auction ring had been built, along with pens and byres that could hold 2,000 cattle and 30,000 sheep. Modernisation and growth continued. It is the official auctioneers to the societies for Luing Cattle, Galloway Cattle, Belted Galloway Cattle, Salers Cattle and the Bluefaced Leicester Sheep Association.

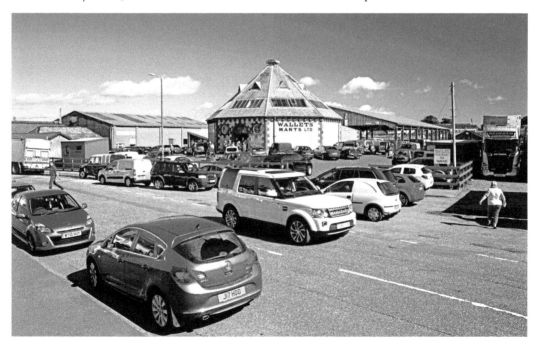

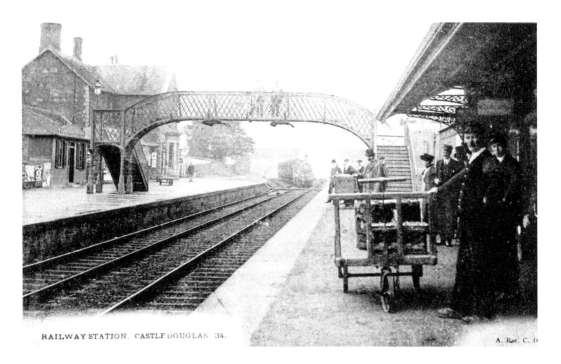

RAILWAY STATION. CASTLE DOUGLAS 34.

A. Rae. C. D.

Railway Station

The railway opened on Monday 7 November 1859. The *Kirkcudbrightshire Advertiser* reported: 'The Magistrates and Town Council, preceded by a banner and band of music marched to the Station just previous to the arrival of the train, which took place at the appointed hour, amidst the shouts and huzzas of the assembled throng.' Not long after the railway opened, a waggon-load of sheep was despatched from Castle Douglas to Liverpool. Up to 200 waggons a day went during the autumn sales.

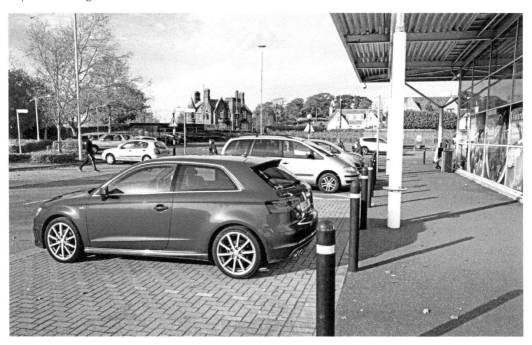

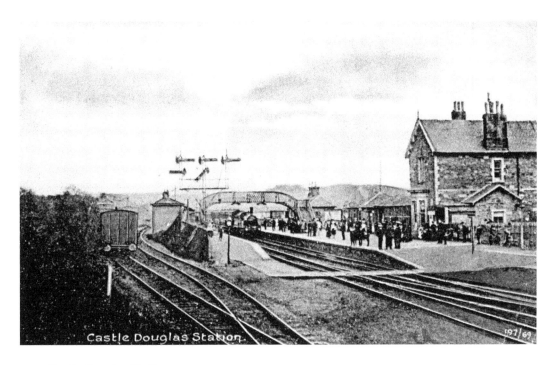

Castle Douglas Station

Castle Douglas Station

In 1861, the Portpatrick Railway line to Castle Douglas was opened. Once again there were cheering crowds to meet the train from Stranraer. The railway directors enjoyed a lunch in the Douglas Arms and celebrations took place in towns along the line. Castle Douglas had a fireworks display. A branch line to Kirkcudbright was opened in 1864. In 1965, Dr Beeching swung his axe and the railway was gone. Behind Tesco is the station yard, now a growing industrial estate.

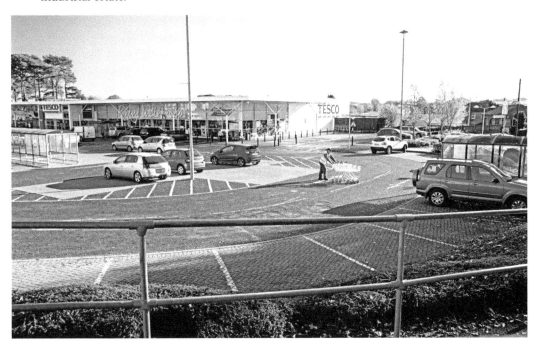

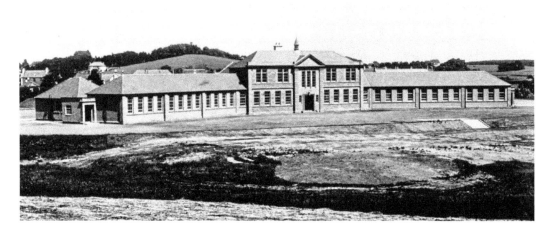

Primary School, Jenny's Loaning

The school in the old photo was built in 1934. The frontage faced away from the town, south to the surrounding fields. It had extensive grounds and playing fields. Children who attended the school in the 1950s and 1960s will remember there were still the remains of a wartime trench. The new school was built in 2009.

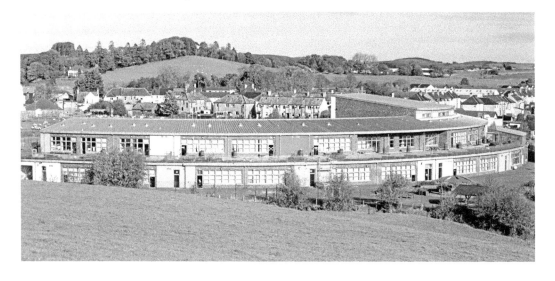

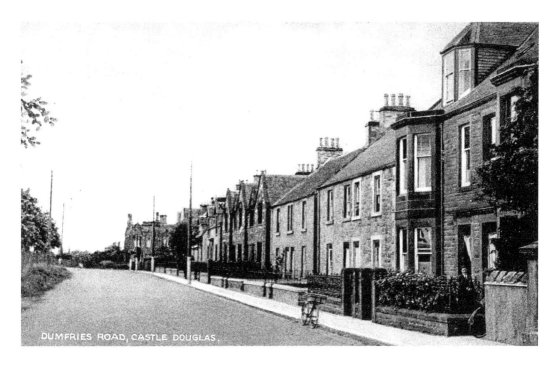

DUMFRIES ROAD, CASTLE DOUGLAS,

Ernespie Road

Now known as Ernespie Road, the name on the old image suggests this is the main road into the town from Dumfries. Much of the heavy traffic is now away from the town thanks to the bypass but it remains a busy road – unlike the days when the first photo was taken where only a lonely bike is parked. The junction on the left in the new photo is the entrance to Tesco supermarket, whose arrival generated much protest.

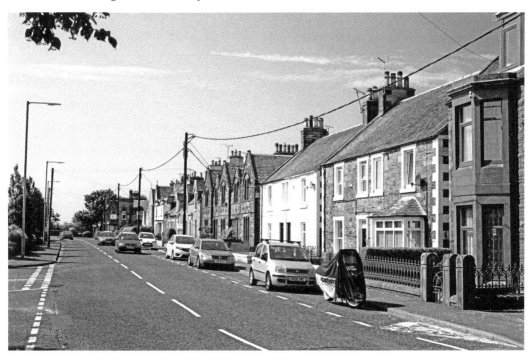

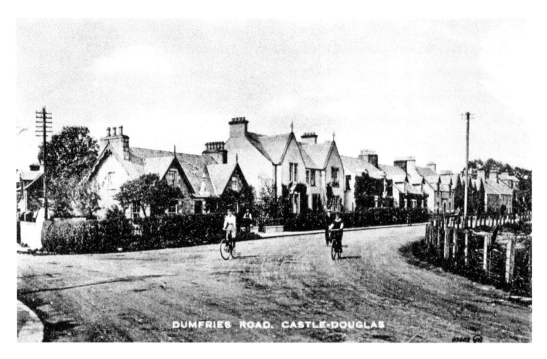

Ernespie Road

Bicycles were a popular mode of transport around the time the old image was taken, whereas now pedestrian crossing lights are necessary to allow people across the busy road. The house on the corner has lost its hedge and tree, replaced by a low wall. The junction on the left turns onto Dunmuir Road.

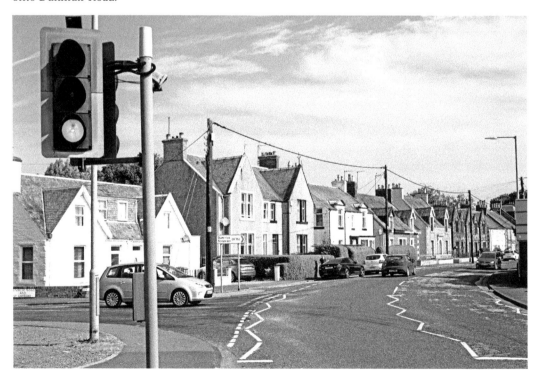

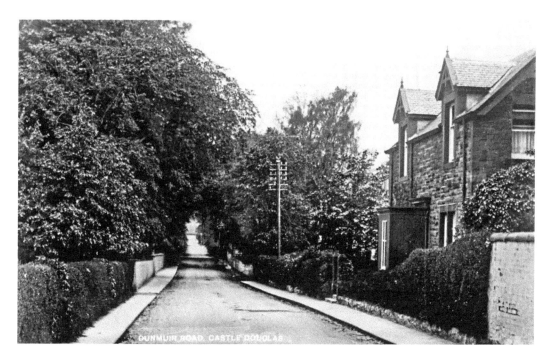

Dunmuir Road

This road leads out of town, past the high school and the site of the old Infectious Diseases Hospital, to the villages of Clarebrand and Kirkpatrick Durham. The road is named after Dunmuir House, hidden behind trees on the left, and Dunmuir Hill, part of which can be seen in the modern photo.

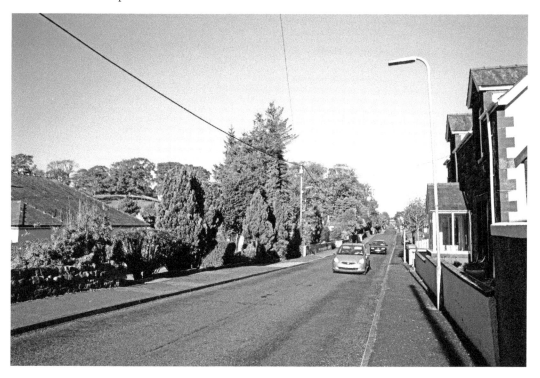

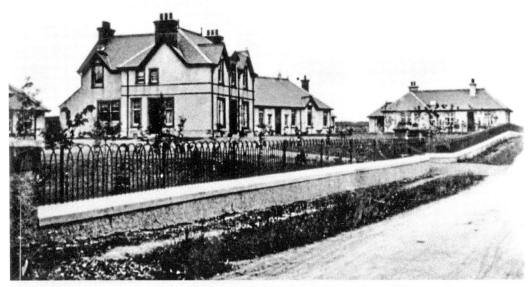

STEWARTRY I.D HOSPITAL, CASTLE DOUGLAS

Infectious Diseases Hospital, Dunmuir Road

When it opened in 1910, the hospital for patients with scarlet fever and diphtheria was situated well out of town. In 1915, the *Dumfries & Galloway Standard* reported that the matron Miss Mackenzie had volunteered her services as a nurse in Serbia. The hospital closed in 1940. It later became a care home for people with learning disabilities. The building has since been demolished and replaced by individual bungalows for users of the care services.

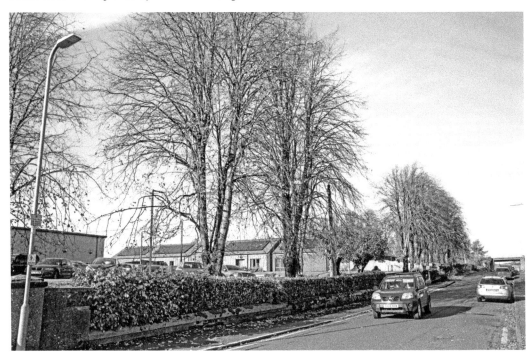

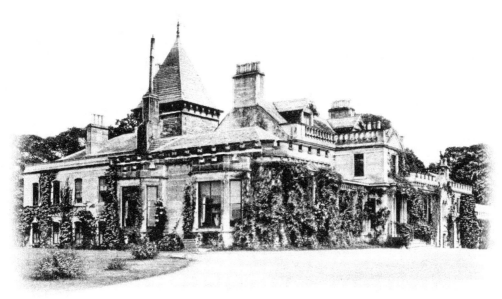

ERNESPIE, CASTLE DOUGLAS.

RELIABLE SERIES.

Urr Valley Hotel, Ernespie Road

A country house hotel set in 14 acres of ground on the edge of the town, it was originally built as a modest two-storey private residence around 1800. In the nineteenth century it was extended twice, with the Jacobean porch added mid-century. Further extension work was done in the twentieth century. It was formerly known as the Ernespie House Hotel. Two standing stones are in the field just off the half-mile drive from the main road.

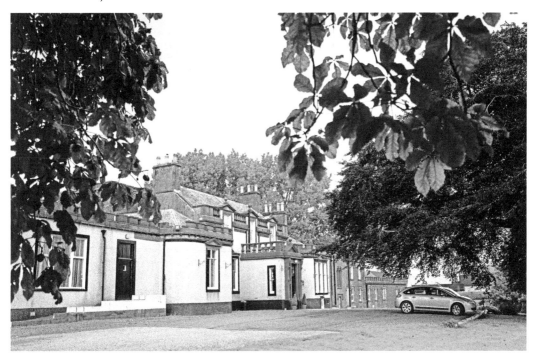

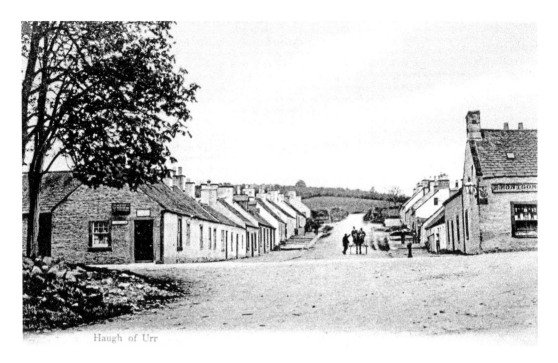

Haugh of Urr

Haugh of Urr Village

Situated beside the River Urr, the village is referred to locally simply as The Haugh (rhymes with loch). The old military road built in the 1600s from Dumfries to Portpatrick runs through the village, intersecting at the crossroads. The building on the left in the old photo was the post office with a shop on the right, both now gone. South of the village is the site of a twelfth-century motte-and-bailey castle, the most extensive such earthwork in Scotland.

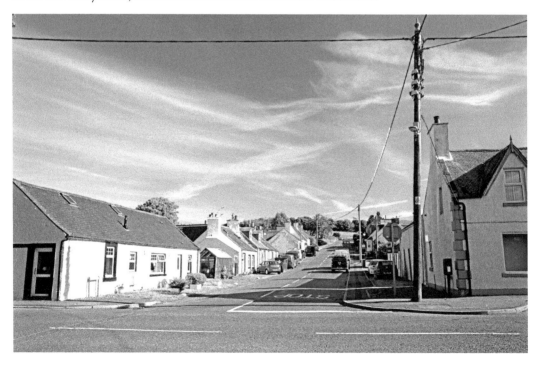

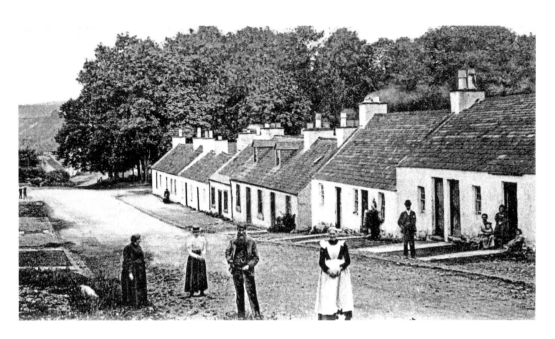

Haugh of Urr Village

Taken looking downhill towards Castle Douglas, the photographer has given a lovely glimpse into the style of dress at the turn of the twentieth century. The gentleman in the foreground is sporting a pocket watch and chain – and a very fine set of whiskers.

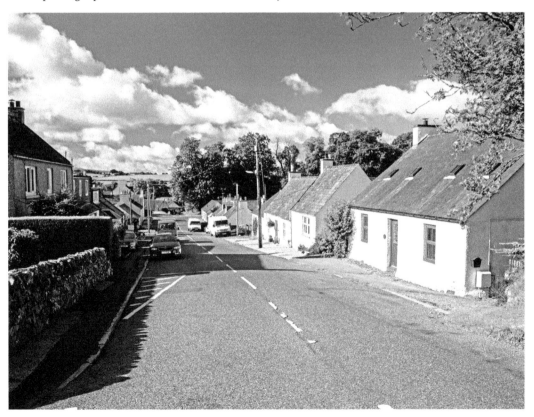

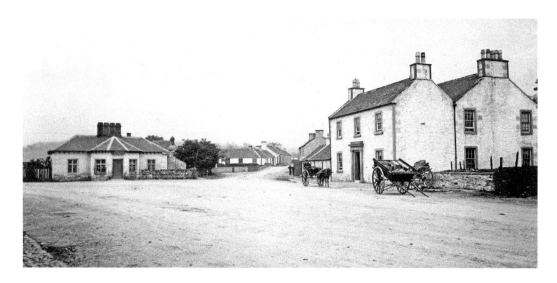

Crocketford Village

Positioned midway between Castle Douglas and Dumfries, and also known as Ninemile Bar, travellers in the eighteenth century paid a toll here. Tollhouse Cottage on the left of the photo was built in 1834. The traffic island with road signs has reduced the spacious feel of the village, though necessary to cope with the volume of traffic nowadays. The Galloway Arms Hotel was originally called New Inn Hotel.

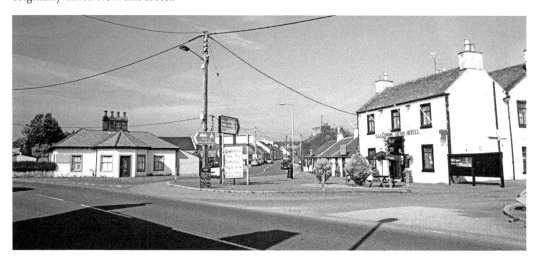

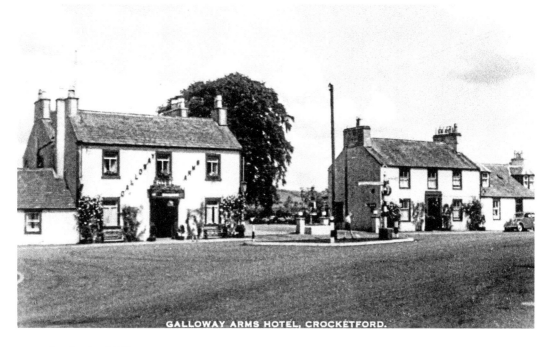

GALLOWAY ARMS HOTEL, CROCKETFORD.

Crocketford Village

In 1787, Crocketford became home to the religious sect the Buchanites, followers of Elspeth Buchan who had been expelled from other towns. She believed she was the woman 'clothed with the sun' in the Book of Revelation (12:1), and immortal. She died in 1791, still convinced she would be resurrected. When the last adherent, Andrew Innes, died in 1846, Elspeth's mummified body was discovered. He left instructions that he should be buried above her so when she ascended, he would too.

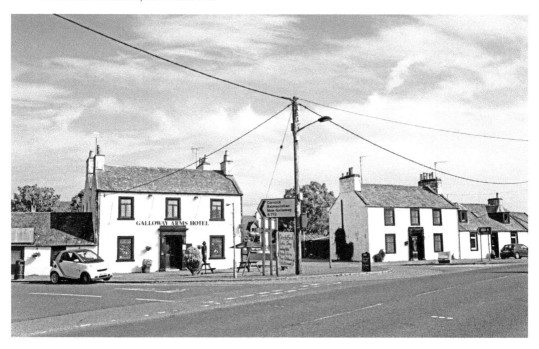

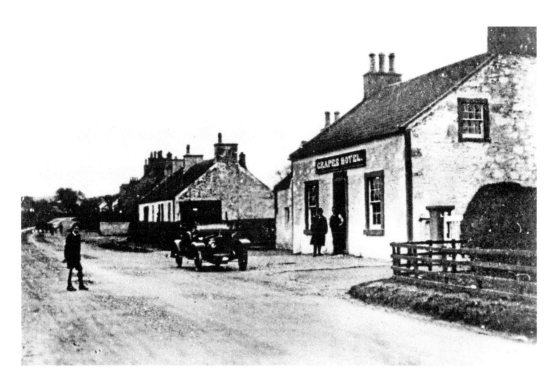

The Grapes Hotel, Springholm

Springholm was a planned village, built in the 1800s on the coach road to Portpatrick. That road is now the Euro route and Springholm is one of only two villages (Crocketford being the other) not bypassed. The Grapes Hotel had a change of name and for a while was called the Reoch, possibly because nearby is Auchenreoch Loch; there's also an Auchenreoch Bridge, an Auchenreoch Cottage and a new housing estate called Reoch Park.

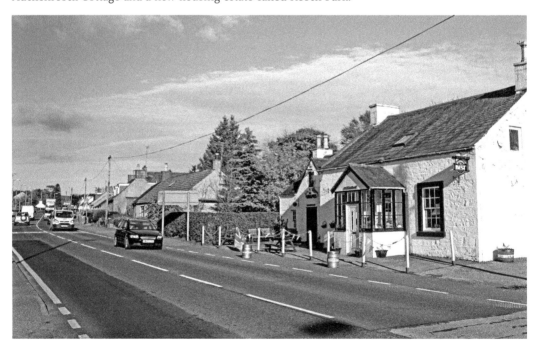

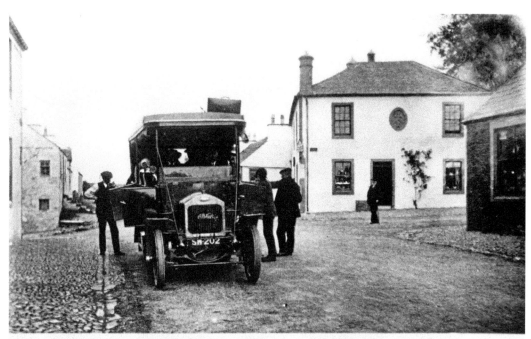

THE MOTOR BUS LEAVING KIRKPATRICK DURHAM.

Kirkpatrick Durham Village

Founded by minister and landowner Dr David Lamont after 1783, the village follows a simple plan of intersecting streets. By 1844, 500 people lived in the village, which boasted seven inns an alehouse and a racecourse. The bus was built by Albion. The square house on St David's Street was built in 1813 as a Masonic lodge – St David's Lodge 295, which gives the street its name.

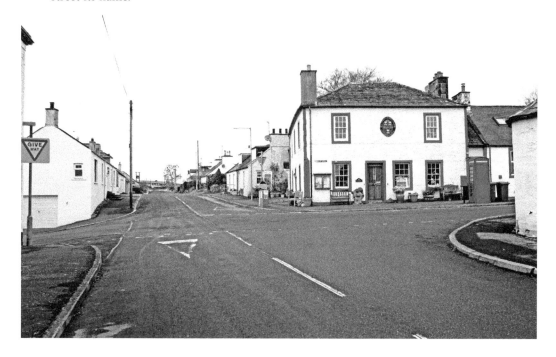

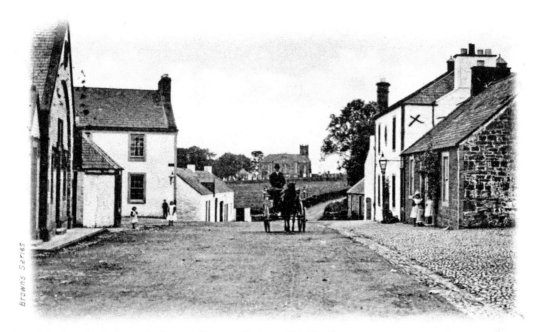

Parish Kirk from St David Street, Kirkpatrick-Durham

Parish Kirk, Kirkpatrick Durham

The church was built in 1849–50 by architect Walter Newall. It replaced an earlier church of 1749. Revd David Lamont who founded the village would have been minister at the previous church from the age of twenty-one until he died aged eighty-three. The old image gives a wonderful glimpse into Victorian village life from the pony and trap to the clothes the children are wearing.

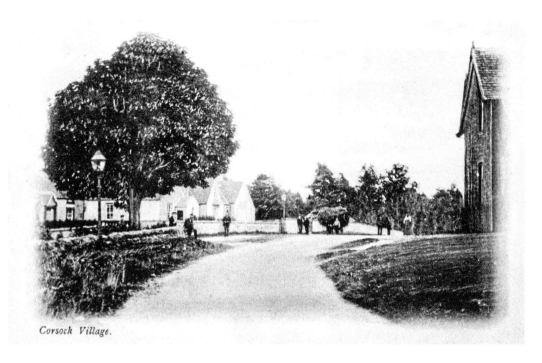

Corsock Village.

Corsock Village

Corsock is a small, picturesque village situated 8 miles north of Castle Douglas. This scene of hay being brought in by a horse and cart would once have been a common sight. As can be seen, gas lamps were still in use. Corsock's primary school has gone and sadly, the pub, Pringles, closed its doors at the beginning of 2016. The village hall still holds events including a Christmas Craft Fair, at which some of the area's top craftspeople bring their goods.

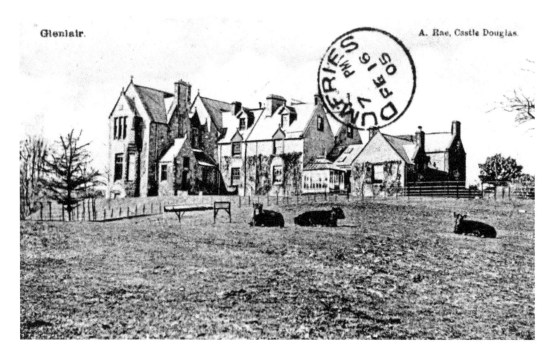

Glenlair. A. Rae, Castle Douglas.

Glenlair, Corsock

The home of renowned scientist James Clerk Maxwell (1831–79) was gutted by fire in 1929. The Ferguson family bought Glenlair in 1950 and set up the Maxwell at Glenlair Trust. Maxwell's equations and writings are difficult for the layman to understand but his work on light and electromagnetism led to the development of radio, television, colour photography, radar and satellite communication. Einstein said of him, 'One scientific epoch ended and another began with James Clerk Maxwell.'

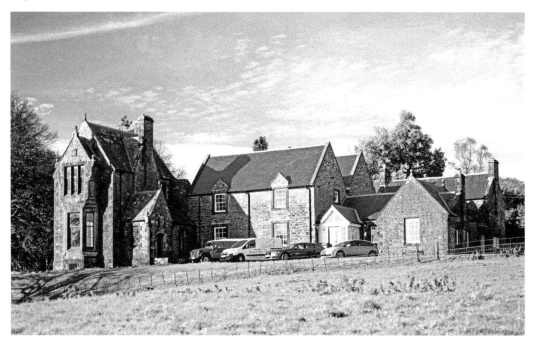

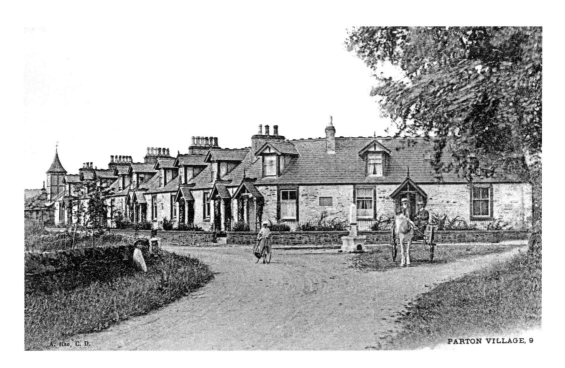

PARTON VILLAGE, 9

Parton Village

The place name 'Parton' has been found in records dating back to at least 1275. The picturesque cottages were originally built to house workers at a slate quarry that closed in the 1890s. Following a flood in 1901, Mr B. R. Murray of Parton House raised the level of the houses. In 1902 there was a reading room and library, post office, seamstress, joiner and blacksmith. He also provided the village hall in 1908.

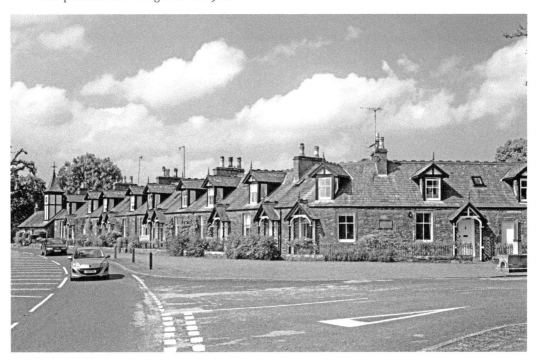

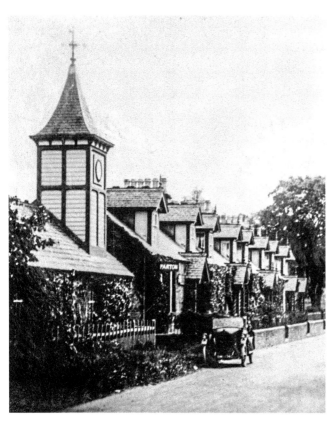

Clock Tower House,
Parton Village

The clock tower was added to
an existing byre, which was
later converted to a communal
laundry. It is now a private
home. Behind the cottages,
Mr Murray built an octagonal
shared privy in the gardens,
which were known by the
villagers as the 'hooses o'
parliament' or the 'bandstand'.
The railway from Stranraer to
London went through Parton
until Beeching swung his axe
in 1965. The station is now a
private house.

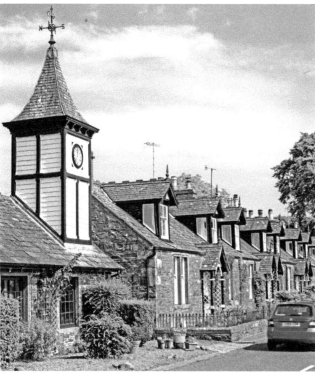

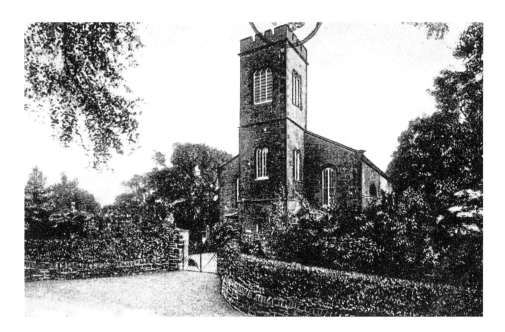

Parton Church, Parton

Designed by architect Walter Newall, the church was built in 1834, replacing an older kirk originally built in 1502 and rebuilt in 1534. Within the ruin of the old kirk, James Clerk Maxwell, Professor of Experimental Physics at Cambridge University, is buried. He was a founding father of modern science, devising various theories and equations on electromagnetism, optics and molecules. Clerk Maxwell was born in Edinburgh and came to live at the family estate at Glenlair, near Parton.

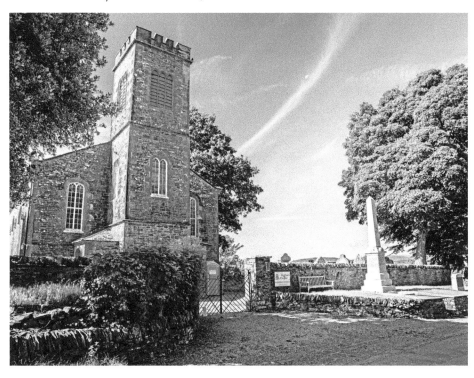

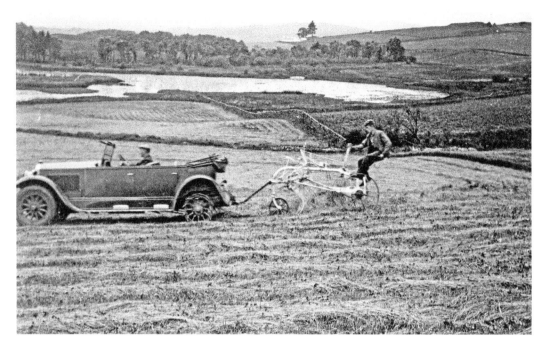

Lochhill Farm, Crossmichael

The car was owned by farmer William Shedden who farmed at Balgerran and Lochhill, where the photograph was taken. The back wheels have been adapted, presumably to provide more traction as the car pulled the hay turner. The photo, probably taken shortly after the Second World War, is looking south-west over Erncrogo Loch.

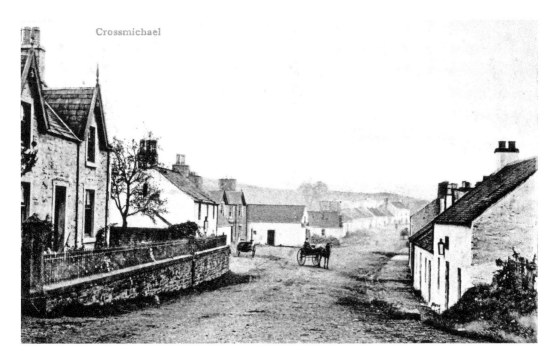

Crossmichael Village Looking South

The village name comes from 'Cross of St Michael', the patron saint of the original church. An annual fair was formerly held at Michaelmas until the mid-nineteenth century. The Thistle Inn is on the left where a car is passing in the recent photo and a horse and cart in the old version. A Roman fort was nearby at Glenlochar. Sixteen other forts, mottes, stone circles and cairns all lie within 3 miles of the village.

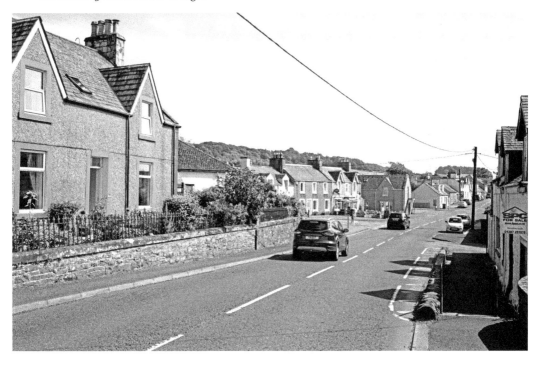

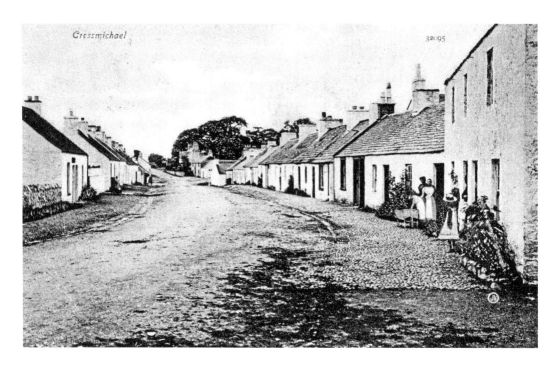

Crossmichael Village Looking North

The church, hidden by trees in the old image, was built in 1751 and stands on the site of an earlier one. The oldest tombstone in the churchyard is dated 1547. The distinctive round bell tower, dating from around 1611, is the only part of the original church to be incorporated into the present one. The churchyard also includes the grave of a young Covenanter, William Graham, shot by dragoons in 1682 during the 'Killing Times'.

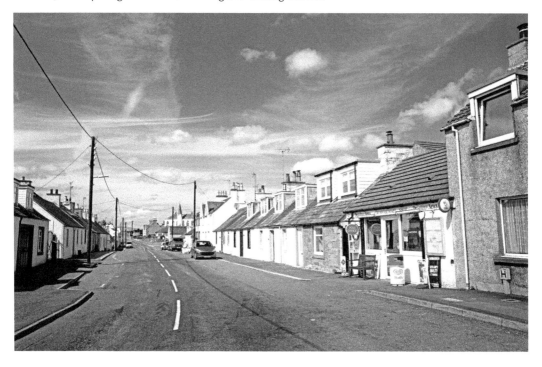

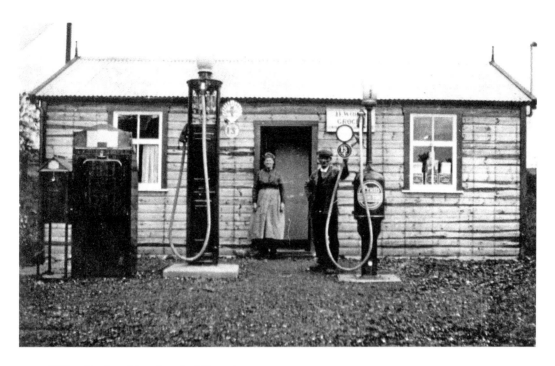

Filling Station, Townhead of Greenlaw

At the crossroads on the Crossmichael Road, only a handful of houses make up Townhead of Greenlaw where the filling station was. The couple – it appears they are Mr and Mrs Wood – look very proud of their petrol pumps. The Shell pump has a price 1s 5d (one shilling and fivepence or around 7p). The couple also ran a grocery shop.

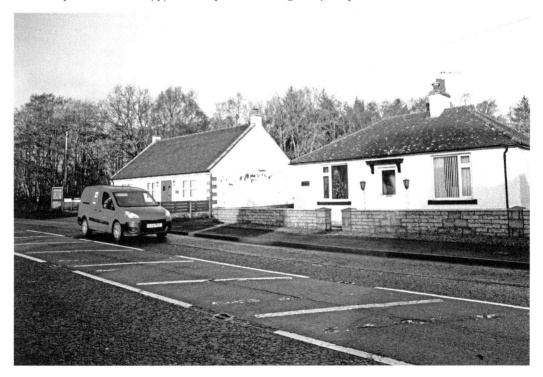

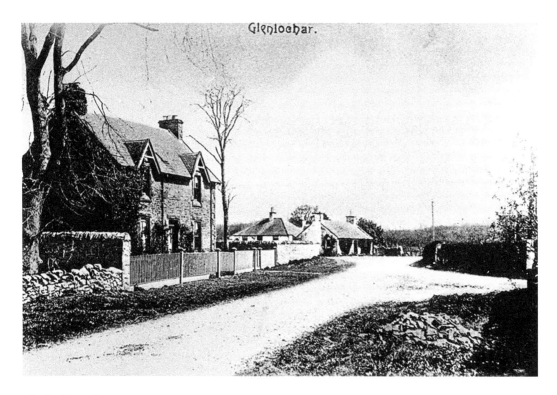

Glenlochar Village

Less than 3 miles from Castle Douglas, the small village of Glenlochar is on the west bank of the River Dee. There are only a handful of houses and the school is now a community centre. The large house in the foreground was the school house.

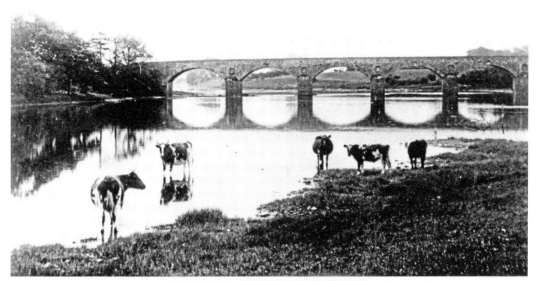

GLENLOCHAR BRIDGE Near LAURIESTON.

Glenlochar Bridge, Glenlochar

The bridge was built in 1780. Part of the Glenlochar Barrage can be seen through one of the arches. The barrage controls the water levels from Loch Ken and the River Dee for hydroelectric power. In 1949, aerial photographs of the area near the bridge showed a clear outline of a Roman camp. An archaeological dig discovered the camp, which would have billeted 1,000 foot soldiers and 200 cavalry.

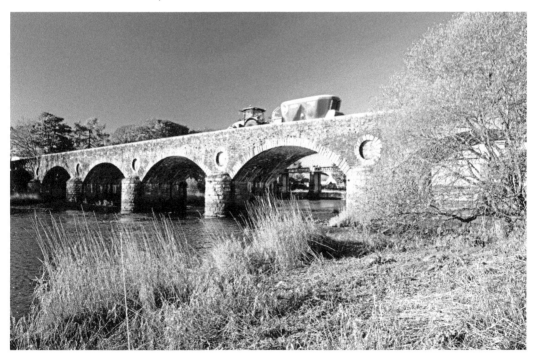

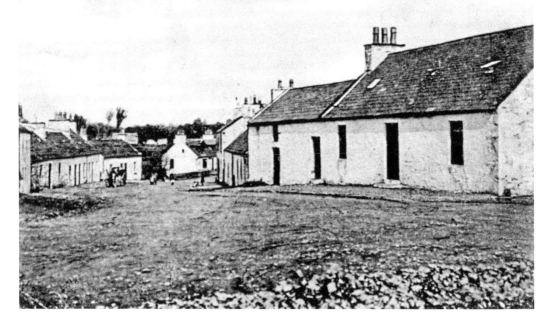

Laurieston Village

The line of cottages on the right of the photo has not altered greatly, though across the road many of the nineteenth-century cottages have been replaced. The horse pulling the cart faced a steep climb up the unpaved road. As with so many villages in the area, Laurieston has lost its school, pub and church, though it has a flourishing photography studio.

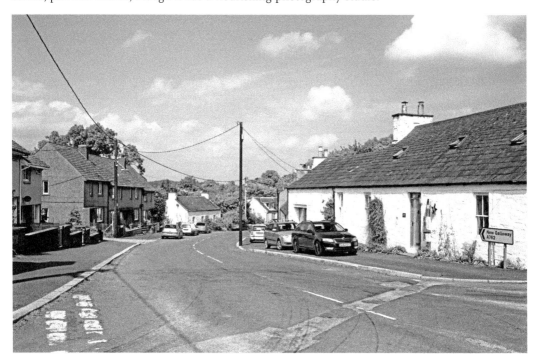

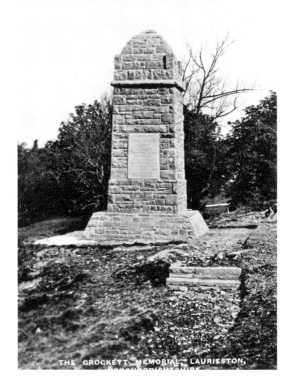

THE CROCKETT MEMORIAL LAURIESTON,

S. R. Crockett Memorial, Laurieston Village

The memorial was erected in 1932 to commemorate one of Scotland's finest and most prolific writers. S. R. Crockett was a bestseller in his time, but as reading tastes changed, he fell out of fashion. The Galloway Raiders was established recently to bring him back to the attention of readers and has republished thirty-two of his Galloway-based works – half of his output. His health was poor and he spent winters in France where he died in 1914. He was only fifty-four.

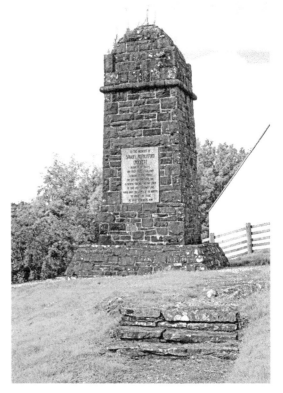

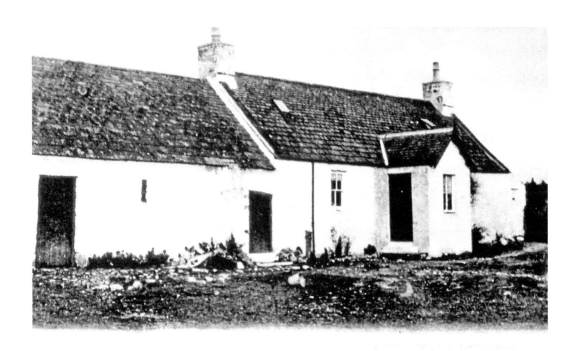

Little Duchrae, Balmaghie

S. R. Crockett was born and spent his early childhood here, attending school in Laurieston before moving to Castle Douglas. He became a minister in the Free Church of Scotland. His collection of stories, *The Stickit Minister*, was an instant success, followed by *The Raiders* and *The Lilac Sunbonnet*. When his books became successful, he resigned from the ministry to focus on his writing.

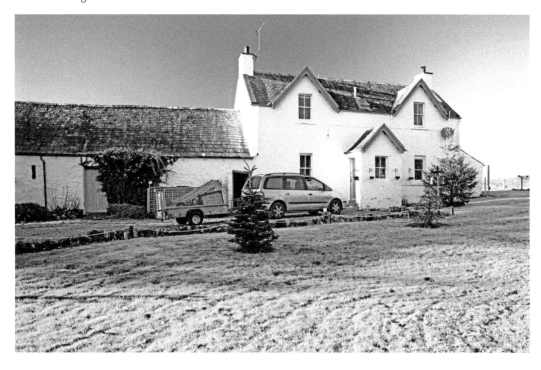

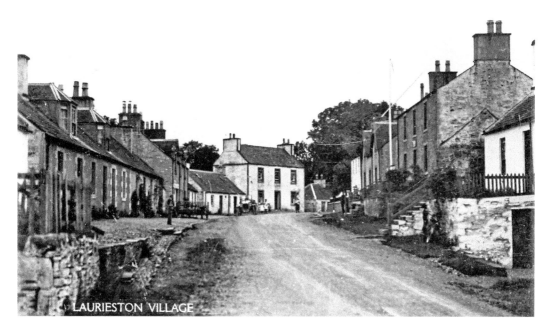

LAURIESTON VILLAGE

Laurieston Village

The village, once known as Clachanpluck, dates back to the fifteenth century. An eighteenth-century landowner, Laurie, changed the name to make his mark in the world, much to the fury of author S. R. Crockett who described him as having 'a bad education and a plentiful lack of taste.' And yes, that is the Queen, waving from a cottage, as she takes part in the village's annual scarecrow competition.

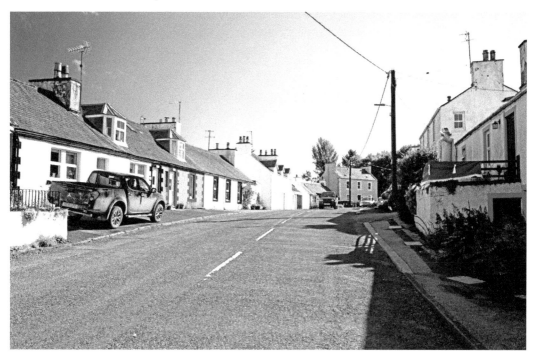

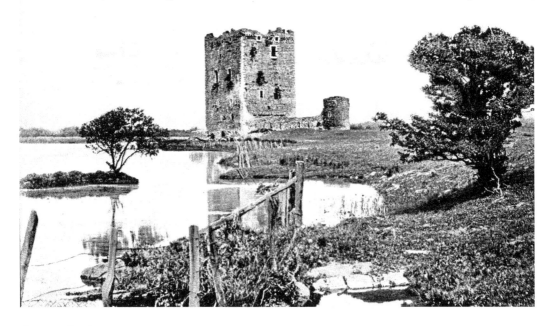

Threave Castle

Built for Sir Archibald Douglas, later the 3rd Earl of Douglas, in the fourteenth century, Threave Castle is on a small island in the River Dee. The imposing tower house was five storeys high with walls 3 metres thick and impregnable artillery defences. The scene of brutal battles, treachery and intrigue, it is now a popular tourist attraction. Visitors ring a bell for the boatman to take them across the river. In 2016, a pair of peregrine falcons took up residence.

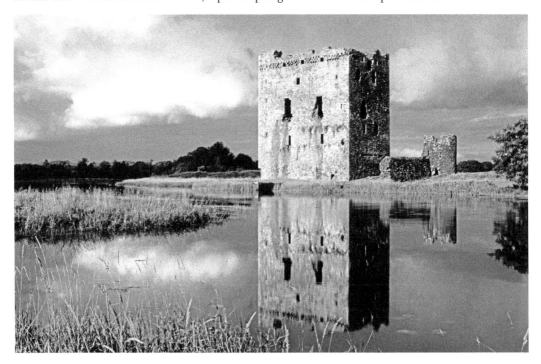

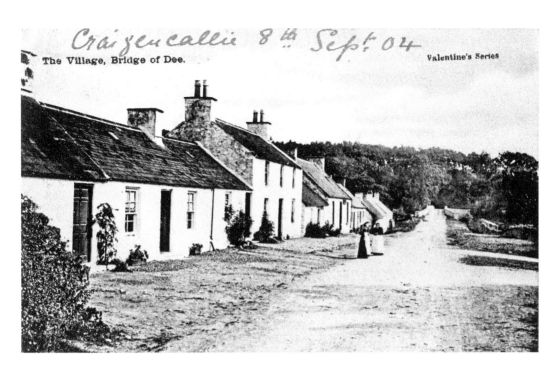

Craigencallie 8th Sept 04

The Village, Bridge of Dee.

Valentine's Series

Bridge of Dee Village

Three miles from Castle Douglas, the village is just off the A75 Euro route. The houses on Bridge Road, which runs through the heart of the village, have undergone much modernisation while still retaining their character. The two women chatting in the road may have been posing for the photographer; one is wearing a most extravagant hat. The village once had its own railway station on the branch line from Castle Douglas to Kirkcudbright.

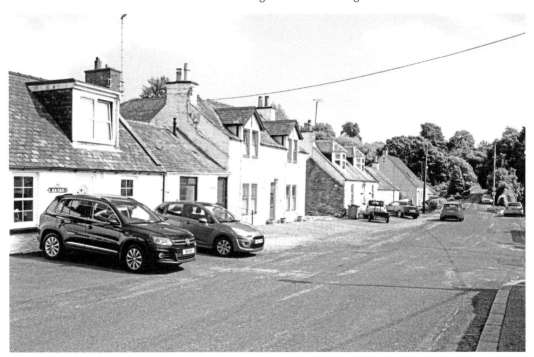

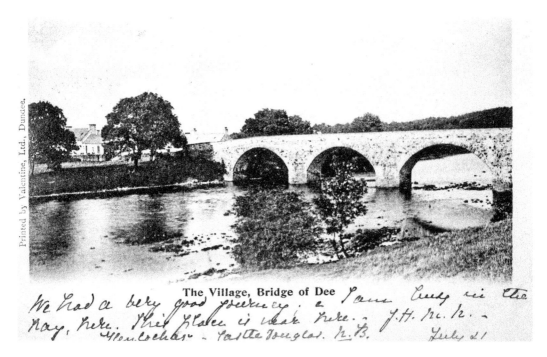

Printed by Valentine, Ltd., Dundee.

The Village, Bridge of Dee

We had a very good journey. a [...] [...] in the May, here. This place is near here. J.H. M. K. — [...] - Castle Douglas. N.B. July 21

Old Bridge of Dee, Bridge of Dee

The narrow (still only one vehicle's width) granite-and-whinstone bridge over the River Dee, from which the village takes its name, was built in 1747 and was part of the main route through Galloway. A row of swans glide along the wall of the house by the river and real swans can often be seen. In 1825, a new bridge, Treife Bridge, was built on the main road from Dumfries to Portpatrick. Widened in 1987, it is now known as Threave Bridge.

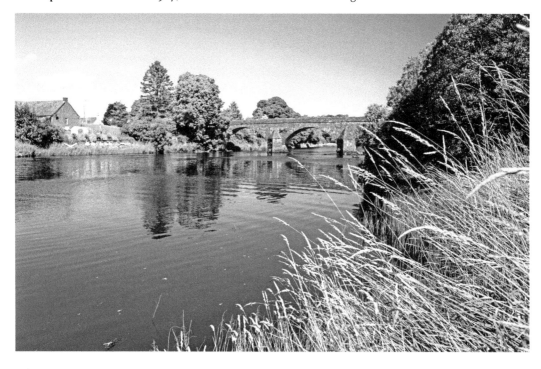

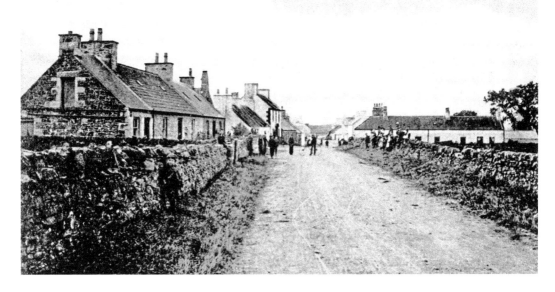

Rhonehouse Village

Now a quiet village without shops, a school or pub, Rhonehouse, also known as Keltonhill, was the site of the annual Keltonhill Fair held in June: '... horse-dealers, cattle-dealers, sellers of sweetmeats, and of spirituous liquors, gypsies, pickpockets, and smugglers ... Through the whole fair-day, one busy tumultuous scene is exhibited of bustling backwards and forwards, bargaining, wooing, carousing, quarrelling.' The fair continued until around 1860, by which time cattle traders were going to market in Castle Douglas.

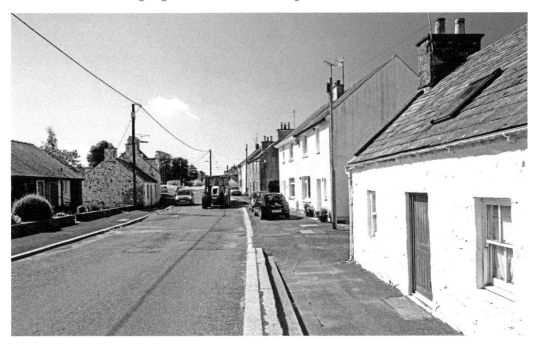

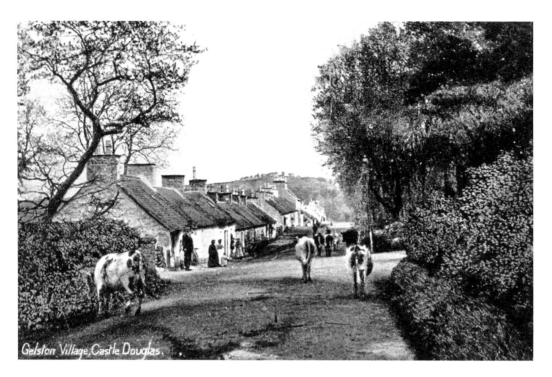

Gelston Village, Castle Douglas.

Gelston Village

Probably owned at one time by the monks of Iona, Gelston passed through many hands until William Douglas acquired it in 1799, building his castle nearby. All the buildings in Gelston's main street are on one side of the road, facing woodland. The man, who seems remarkably tall, watching the cows amble through the village is standing in front of the village water pump. The woman in the recent photo sits outside the village hall waiting for the bus.

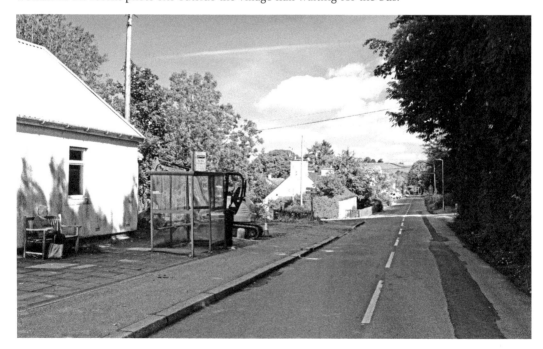

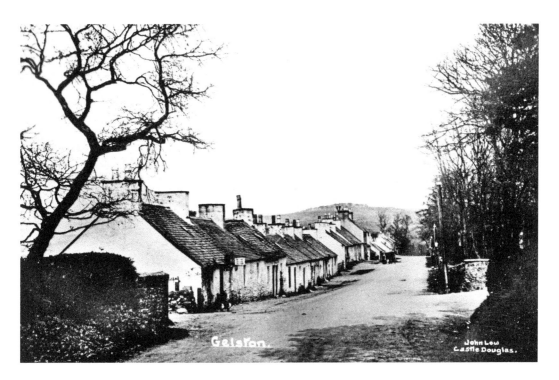

Gelston Village

The Old Cottars cottage at the crossroads was probably built around 250 years ago. It has had several name changes as well as extensive renovation taking in two other cottages. It was once called Griddle Cottage and was possibly an inn. The sign outside the cottage in the old photograph says 'Post Office Public Telephone'.

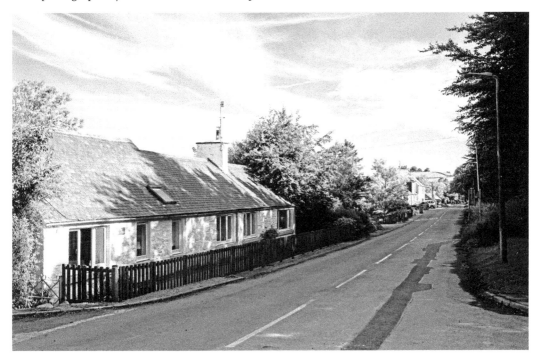

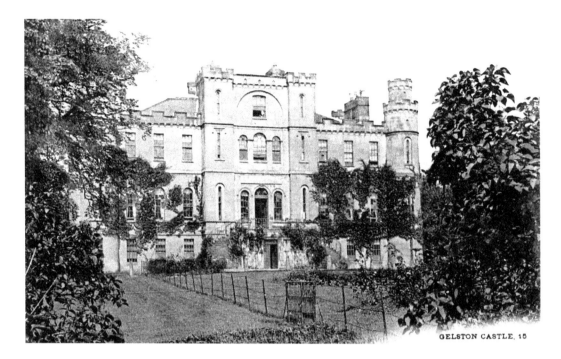

GELSTON CASTLE, 15

Gelston Castle, Gelston

Built by Sir William Douglas, Castle Douglas's founder, around 1805, the castle is close to Gelston village, 3 miles from Castle Douglas. Sir William died in 1809 and it passed to his niece. During the Second World War it was home to disabled boys evacuated from Glasgow. Modernisation costs were prohibitive and the roof was removed to escape paying rates. The Scott family bought the estate in 1973; the current owners occupy what was once the head gardener's house and run a self-catering business.

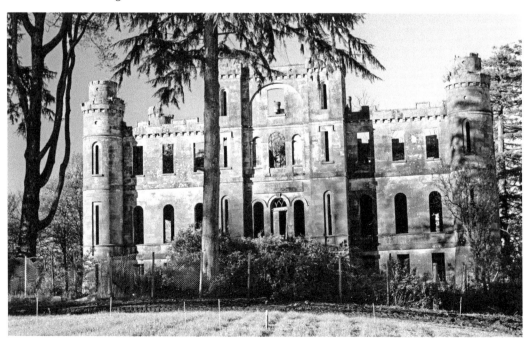

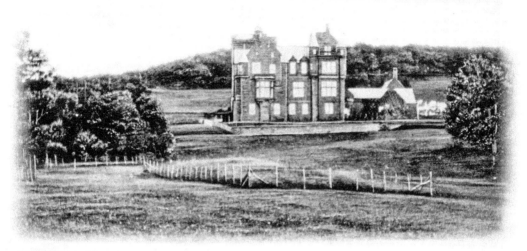

THREAVE HOUSE, CASTLE DOUGLAS.

Threave House, Threave Estate

Threave House was built in Scottish Baronial style in 1872 by William Gordon, who had bought the estate. His grandson, Major Alan Gordon, passed the house and estate to the National Trust for Scotland (NTS) in 1948. The NTS maintain and develop the stunning gardens around Threave House as a visitor attraction. Part of the house accommodates students of the NTS's School of Heritage Gardening. The public rooms have been restored to 1930s grandeur and guided tours are available.

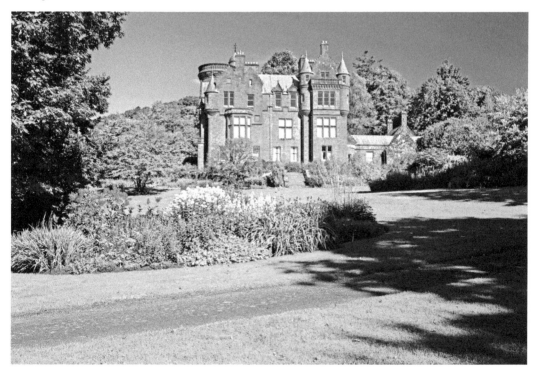

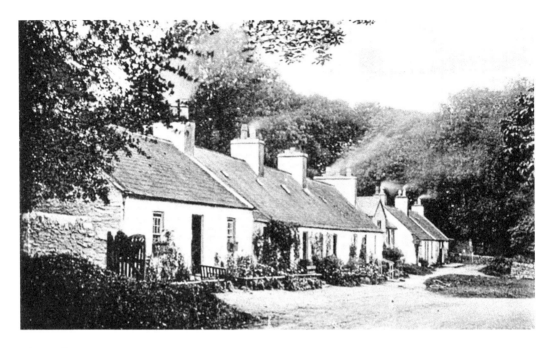

The Buchan

Opposite Carlingwark Loch, these cottages have stood for centuries. Once, a second row of cottages was situated where the road is now. Local tradition maintains that Mons Meg, a bombard gun, was forged at the smithy here in 1455 for James II's attack on Threave Castle. Now at Edinburgh Castle, it seems it was gifted by Duke Philip of Burgundy in 1457 and was made in Mons, Belgium. An older road into town continued from here, past where Carlingwark House stands and on to Carlingwark Hill.

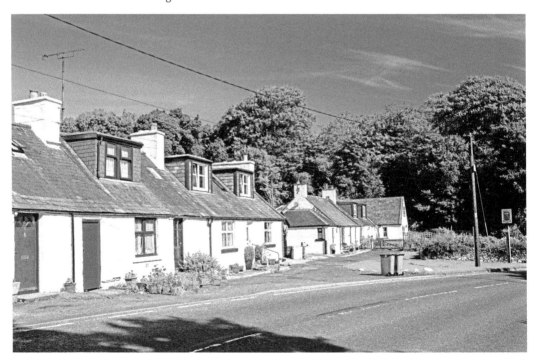

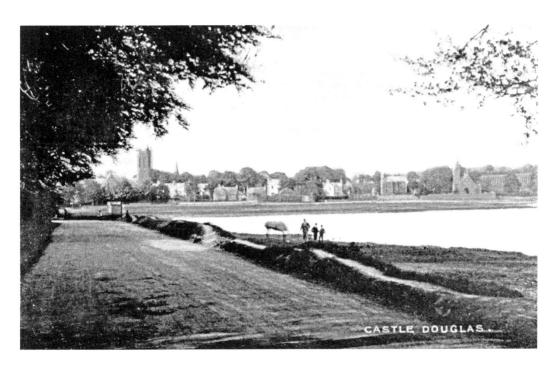

Carlingwark Loch

Over the years, the loch has given up some of its secrets. In 1868, fishermen hauled up a cauldron made from thin plates of bronze riveted together, which held a hoard of tools, a few weapons, high-quality native craft work and a few Roman objects. It had been thrown into the loch between AD 80 and 200 as an offering to the gods. The Carlingwark Cauldron is now in National Museums Scotland in Edinburgh.

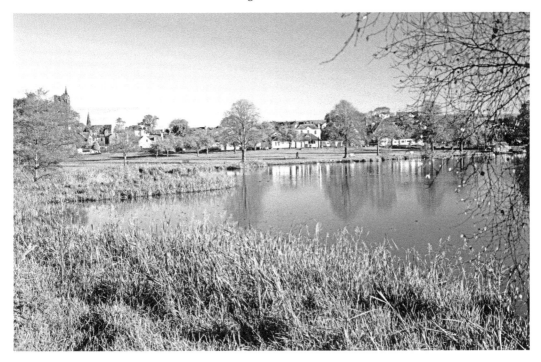

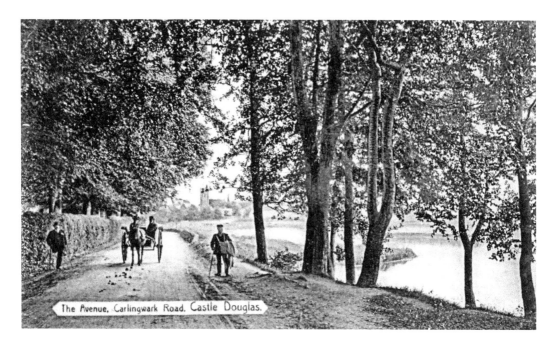

The Avenue, Carlingwark Road. Castle Douglas.

The Avenue, Carlingwark Road

The road out of Castle Douglas towards the Buchan skirts Carlingwark Loch. The town owes its origins to the marl found in the loch, which was used as a fertiliser. Alexander Gordon partially drained the loch and cut a canal between the loch and River Dee to facilitate transport. The small cluster of cottages called Causewayend grew until, by the early 1790s, around 600 people lived in what was now called Carlingwark. Unfortunately, overuse of marl proved counterproductive and the market collapsed.

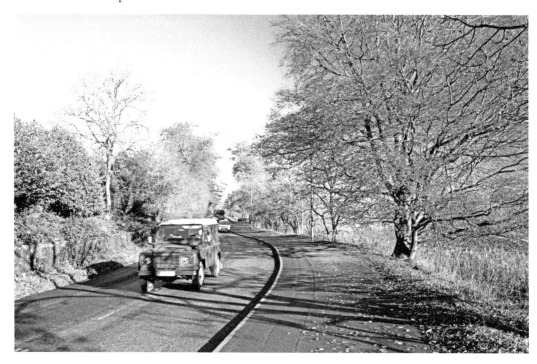

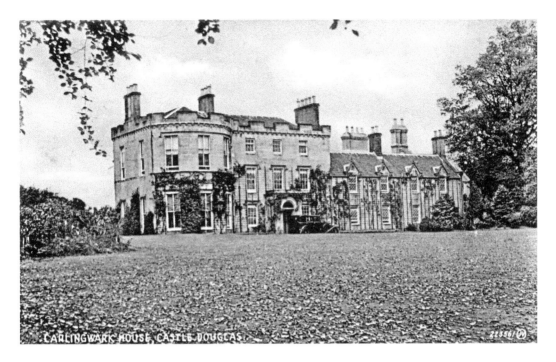

Carlingwark House

This former mansion house was built around 1840 with a late nineteenth-century extension added. It is now a residential care home. Further alterations and extensions were carried out in the twentieth century when it was owned by Dumfries and Galloway Regional Council.

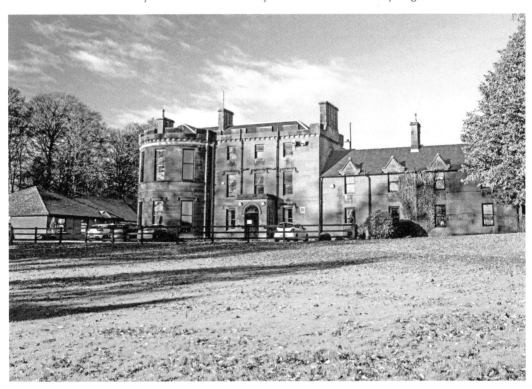

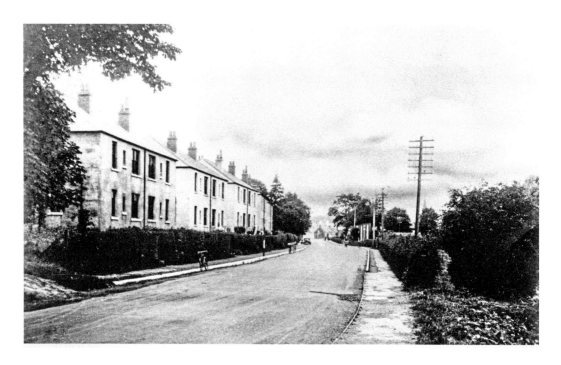

Threave Terrace

When these flats were built, no one would have heard of satellite dishes for our televisions. On the main road out of Castle Douglas, the flats on Threave Terrace are directly opposite Carlingwark Loch and the park. Originally the flats were council-owned but many are now in private ownership. Before the bypass was opened traffic, including articulated lorries, to and from Stranraer and Ireland passed along here.

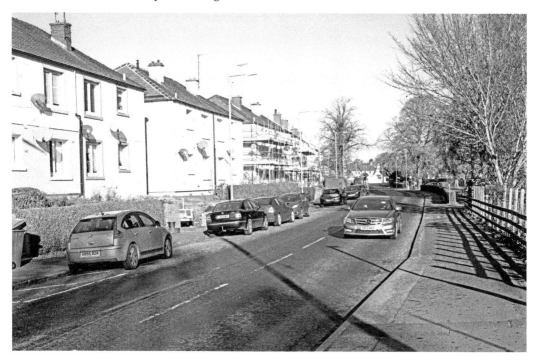

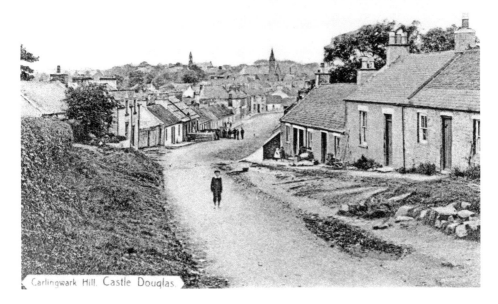

Carlingwark Hill. Castle Douglas.

Carlingwark Hill

Now called Carlingwark Street, this was the route that previously led past Carlingwark House to the Buchan. The spire of the United Presbyterian Church on Abercromby Road is clearly visible in the old photo. It was removed some years ago. The spire to the right of it is St John's Roman Catholic Church. A group of men, a horse and cart, and a man on the roof of the cottage, which has a low wall in front, indicate some kind of work activity happening.

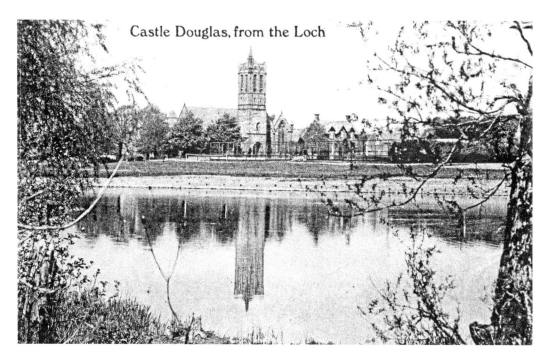

Castle Douglas, from the Loch

Carlingwark Loch I

Looking across the loch towards the town, the church in the foreground, formerly St Andrews, is now the Fullerton Theatre. Sympathetically transformed and professionally equipped, it is run by volunteers. The Outdoor Activities Centre organises kayaking and other water-based activities for schools around the region. The mature trees now hide the town clock tower, which can be glimpsed in the old picture.

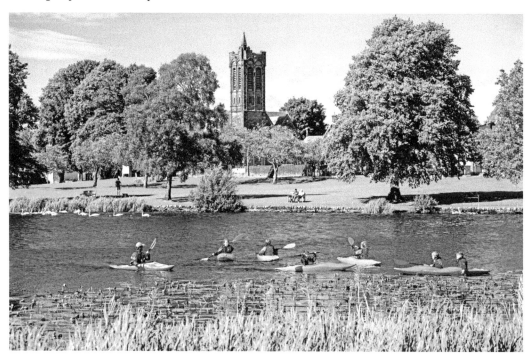

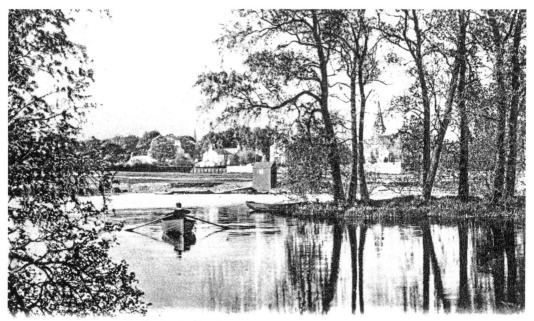

Carlingwark Loch, Castle Douglas

Carlingwark Loch II

St Ninian's Episcopal Church can be clearly seen to the left with its spire, and then without. It was removed in 1950 following an outbreak of woodworm. Although none are showing in our photos, the loch has seven islands. When the loch was drained in 1765, it was discovered that two were Iron Age crannogs built of oak piles sunk into the mud. Two dugout canoes and a planking floor were found.

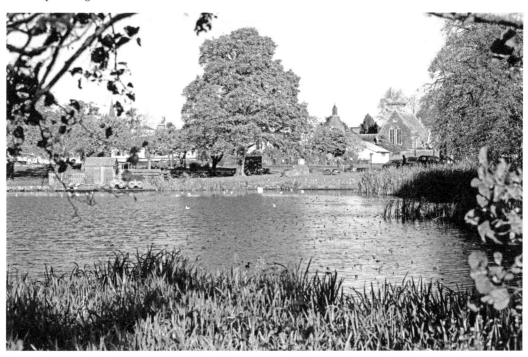

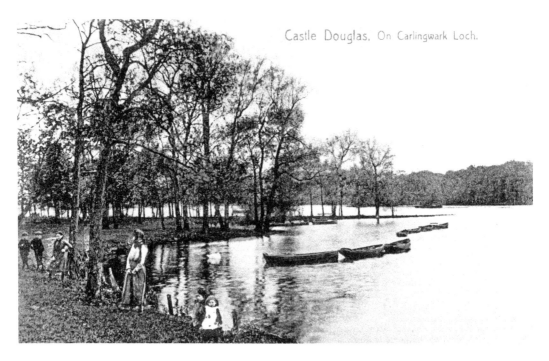

Castle Douglas, On Carlingwark Loch.

Carlingwark Loch III

Lochside Park was once the town common, where people could graze their animals. Peat was also cut from the edges of the loch and in the spring there was the 'blanket fair'. Housewives would descend on the common, light fires and heat water in pots in which to wash their blankets, which were then spread out to dry. S. R. Crockett remembered how he and his friends used to take the blankets and tie them to trees.

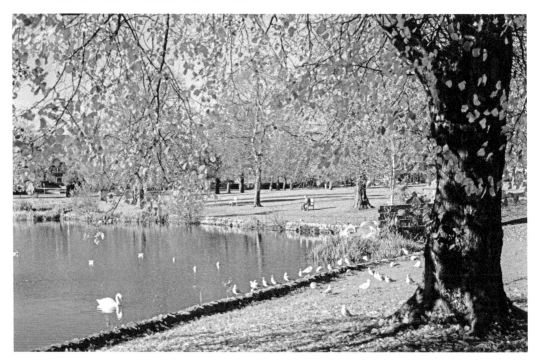

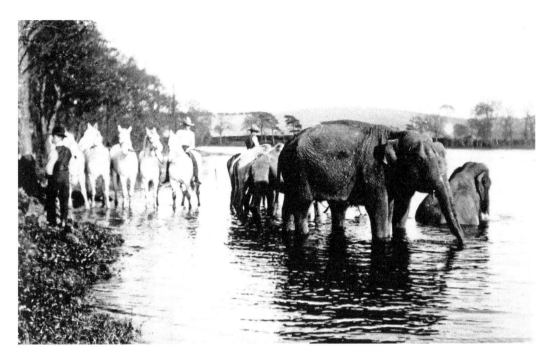

Carlingwark Loch IV

This is not a sight we are ever likely to see again, for which the ducks and swans are probably grateful. Circus horses and elephants take advantage of the loch to enjoy a paddle – one elephant looks like he is going to have a good wallow. The swans enjoy the tourist season, seeing visitors as a source of titbits and have even been known to wander up to the caravans looking for food.

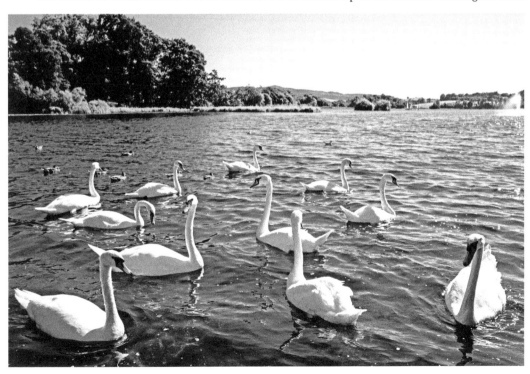

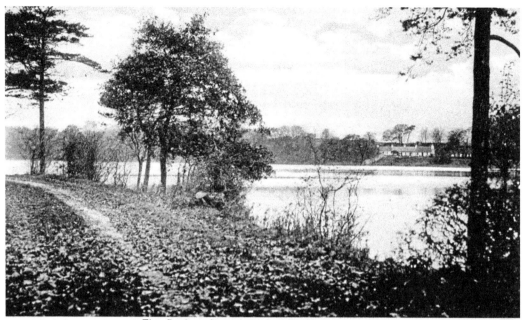

The Buchan from Lover's Walk, Castle Douglas

Lovers' Walk, Carlingwark Loch

The path only goes beside the loch part way because of the mass of reeds, but continues as a circular walk through pastureland to Kelton, Threave Gardens and the Buchan, seen on the far side of the loch. At the southern end of the loch is Fir Island where Edward I shod his horses in 1300. It is also known to locals of a certain vintage (rowing to the island was not always banned) as Dog Island because of a memorial erected in 1863 to Lady Abercromby's dog, Prince.

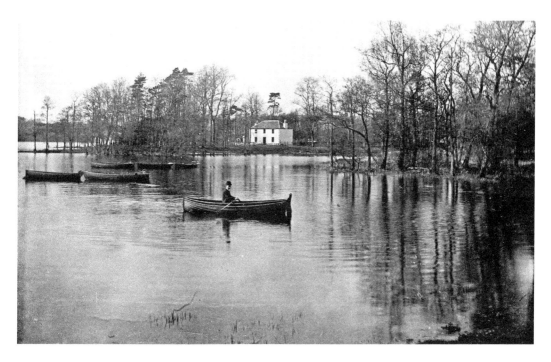

Carlingwark Loch

The gentleman rowing a boat on the loch in a picture taken around the turn of the twentieth century is wearing a bowler hat. Boats for public hire are now on the other side of the peninsula. The white building, almost hidden by trees in the modern photo, is Isle House, once tenanted by a park gardener and his family. It is now the Carlingwark Activity Centre where various water activities and accommodation can be booked.

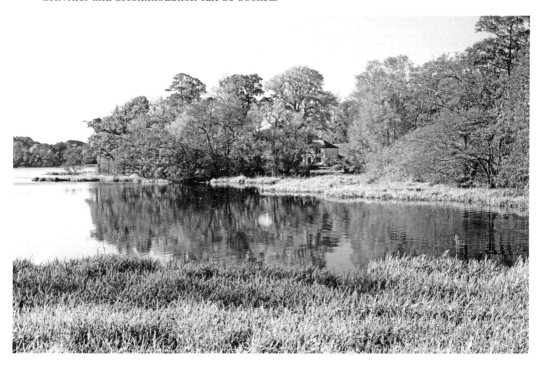

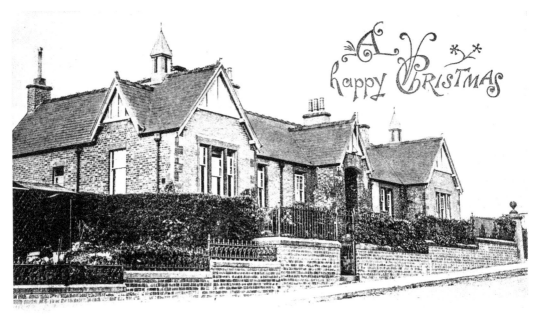

Cottage Hospital, Castle Douglas

The Galloway Series. John Low, Castle Douglas

Castle Douglas Hospital, Academy Street

The cottage, now community, hospital in Castle Douglas was built in 1897 to commemorate Queen Victoria's Diamond Jubilee and opened on 13 October 1899. It had two wards and one private room. In 1901, the Victoria Ward was added with a further extension opening in 1935. By 1948 it had thirty-two beds with a small operating room and X-ray department. Today it has twenty-one beds and a physiotherapy department.

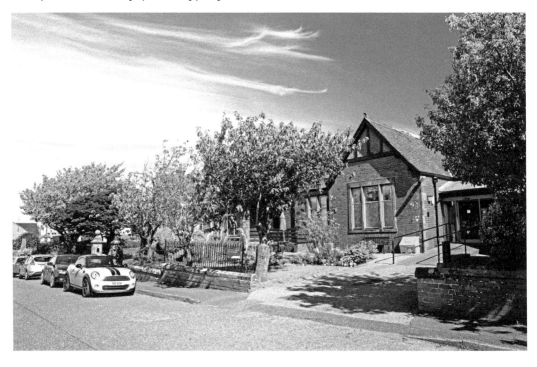

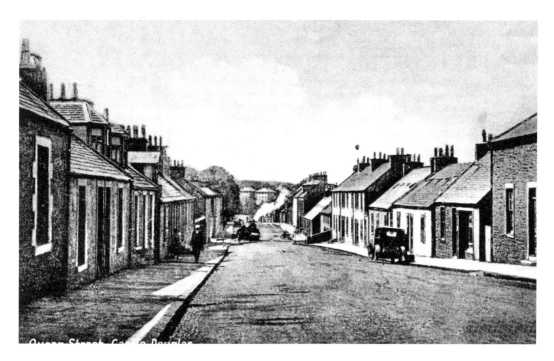

Queen Street

One of the three main streets in the town, Queen Street, to the east of King Street, is mainly residential with a great variety of architectural styles. According to Jean Gibson in her book *Foot Forward in Castle Douglas,* the street was once more industrial and had a tannery and a brewery. What appears to be a steamroller is working on the road surface.

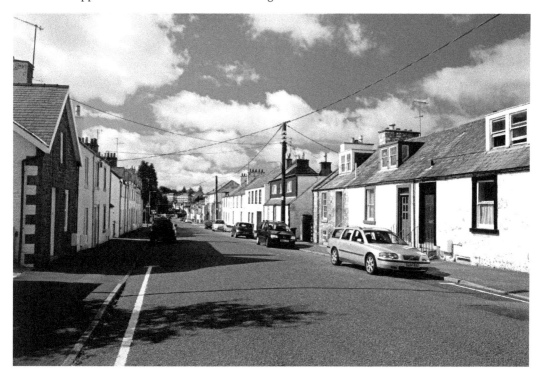

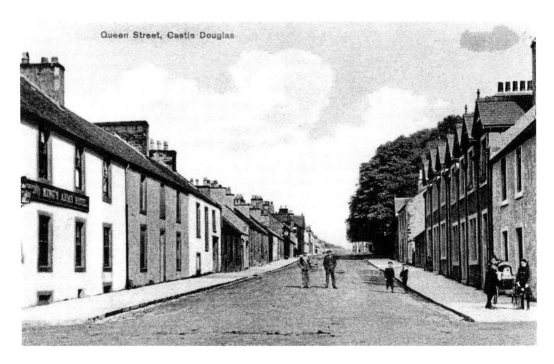

Queen Street, Castle Douglas

Queen Street, From the Junction with St Andrew Street

The entrance to the King's Arms Hotel is around the corner on St Andrew Street. The hotel, like others in the town, was once a posting inn. It has been greatly extended over the years. Some of the houses further up the street have the once-traditional steps with railings leading from pavement to front door. Young girls pushing a baby in a pram is no longer the common sight it once was and I wish we knew what the man with the basket was delivering.

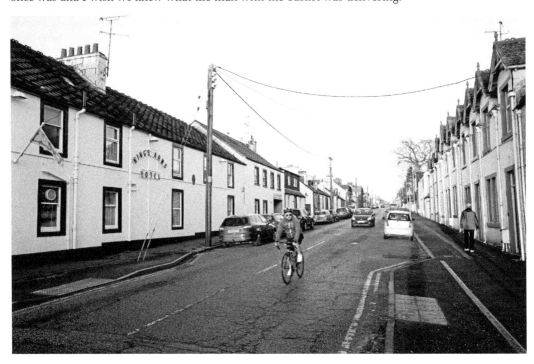

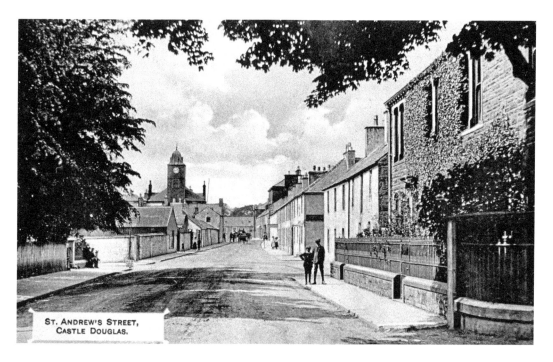

ST. ANDREW'S STREET, CASTLE DOUGLAS.

St Andrew Street

The street intersects Queen Street, King Street and Cotton Street, giving a good view of both the old and the new clock tower. The building on the left is Palace Court flats where the cinema was, and directly opposite is the King's Arms Hotel. On the corner of Queen Street and St Andrew Street, the first building is the Stewartry branch of The Red Cross.

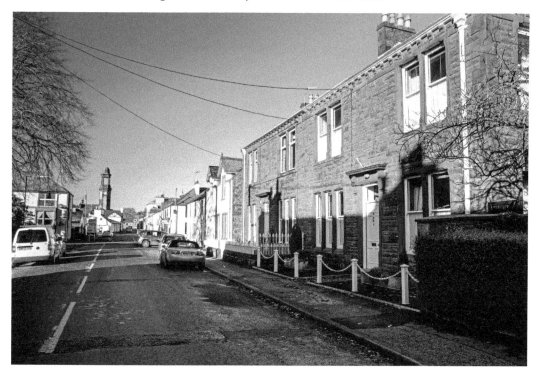

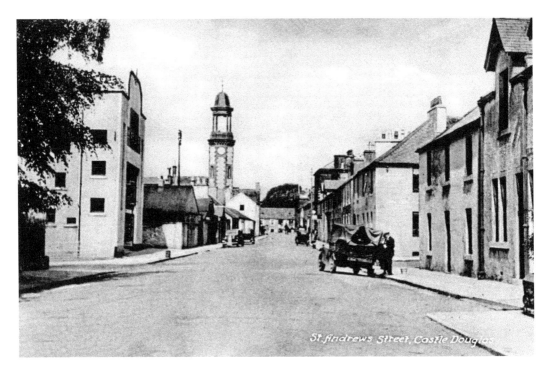

St Andrew Street

The old photo has been taken at a later date than the previous one of St Andrew Street. The Palace Cinema would have been recently opened and horses have given way to vehicles. Just after Palace Court is Hazel's antique and second-hand furniture shop. Further along towards King Street is the recently opened Earth's Crust, which sells artisan bread.

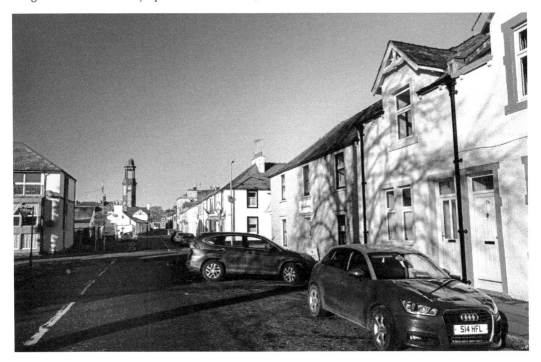

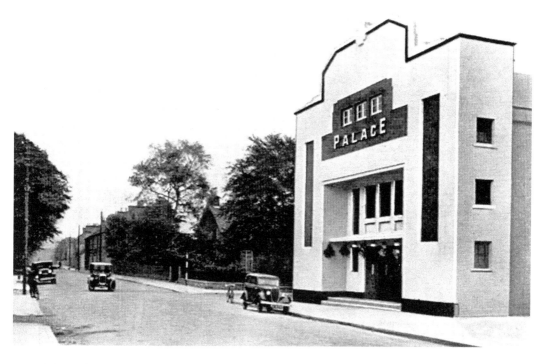

Palace Cinema, St Andrew Street

Built on the site of former stables of the King's Arms Hotel opposite, the Palace Cinema opened in 1930. A popular feature with courting couples was the 'double seats' in the back row. It closed around 1987 and was converted into a bingo hall. This too was closed by 1997, and the building was later demolished and replaced with a block of flats named, appropriately, Palace Court.

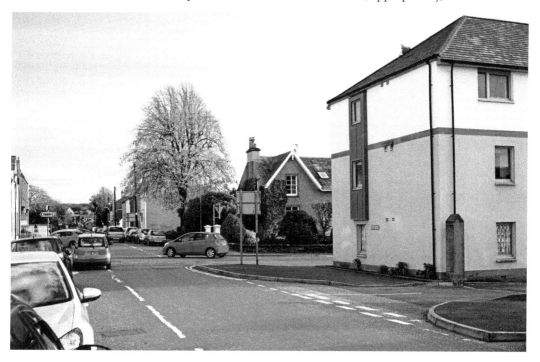

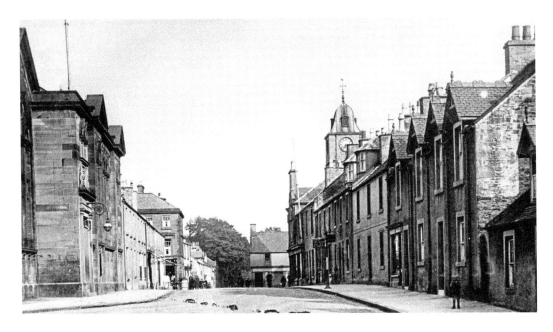

Town Hall, St Andrew Street

Built in 1863, with an extension added in 1902, the red-sandstone town hall displays the burgh's arms above the entrance. As well as the main hall there is a lesser hall, meeting room and conference room. There was also a library and reading room in connection with the Mechanics Institute. In the older photograph, the old clock tower can be seen. The intervening years have seen a huge increase in traffic in the street – and a decrease in chimney pots.

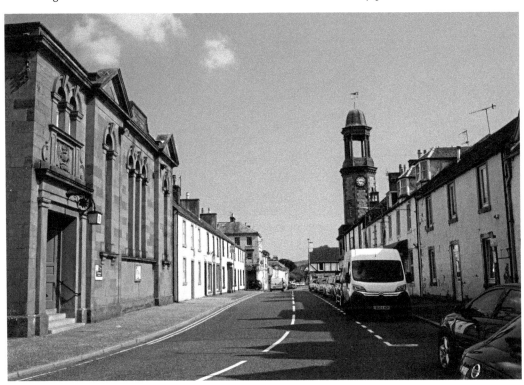

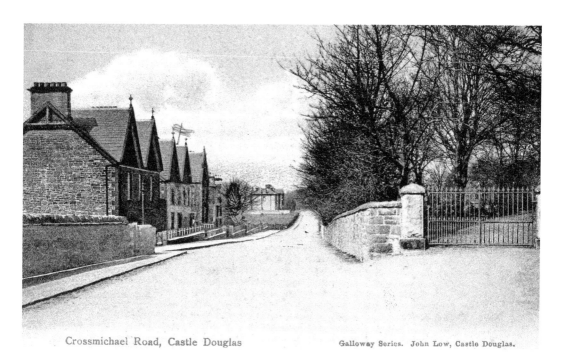

Crossmichael Road, Castle Douglas Galloway Series. John Low, Castle Douglas.

Abercromby Road/Crossmichael Road

Abercromby Road was named in honour of Lady Abercromby, Sir William Douglas's niece. Locally, the road is just as often called Crossmichael Road. In this 1913 picture, the road crosses what was the bridge over the railway line. The town briefly had a second station called St Andrew Street, built because of a ruling that stated all railway lines had to be double at a junction. Passengers making a train connection were taken by road to the main station at the top of the town.

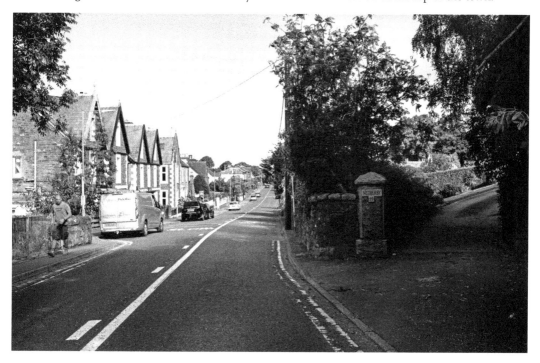

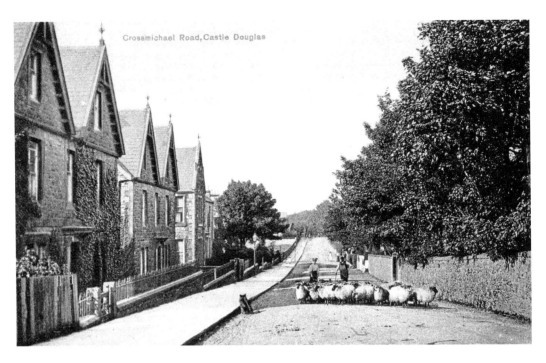

Crossmichael Road, Castle Douglas

Abercromby Road

Although officially called Abercromby, local people usually refer to it as Crossmichael Road. From the decidedly rural aspect in the old picture, so many changes have occurred that only the houses on the left make it recognisable as the same place. The only modern touches are the few gas lights. The black-faced sheep are perhaps being driven to market. The dog, its back to the photographer, appears to be camera shy.

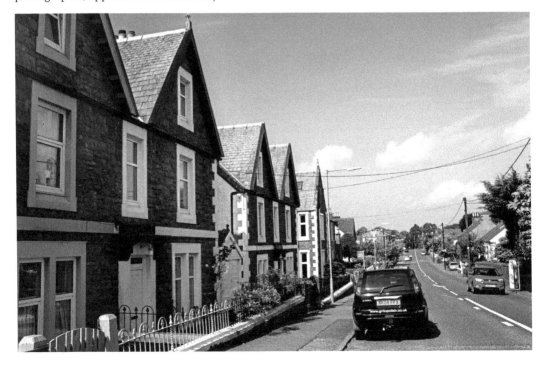

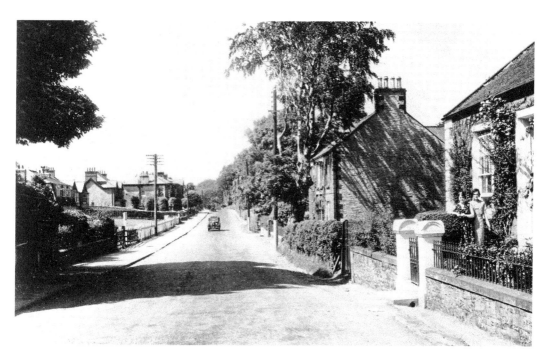

Abercromby Road/Crossmichael Road

A Tennent's delivery van is emerging from the golf course on the left of the 'today' photo. It looks like the two women in the garden of the house on the right are enjoying good weather, both wearing summer dresses. Over the years the road has retained its diverse range of architectural styles. Drivers today, though, need to adopt a less nonchalant style of driving and keep to the left rather than meander down the middle of the road.

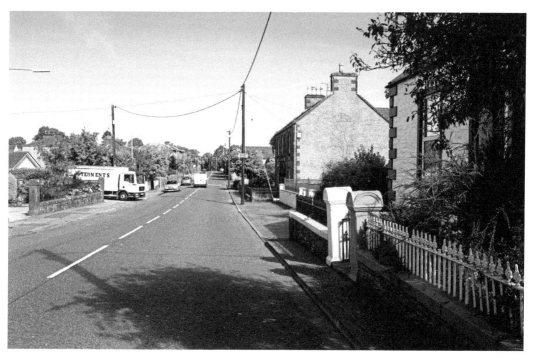

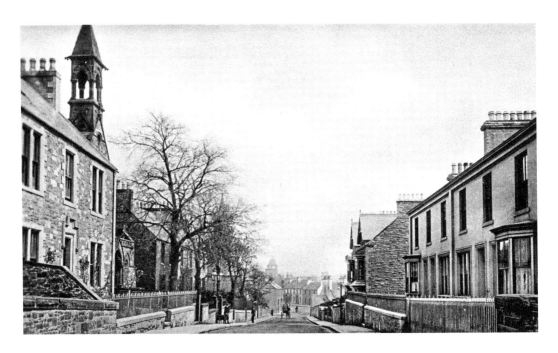

Abercromby Road, Looking Towards the Town

According to *Maxwell's Guide Book to The Stewartry of Kirkcudbright* (1908), there were then seven churches in the town. Two of those were on Abercromby Road. Trinity United Free Church, now without its belfry, has been converted into flats. The congregation amalgamated with the church in Queen Street. Further down, partly hidden by trees in the old image, St John's Roman Catholic Church is now a venue that can be hired for events.

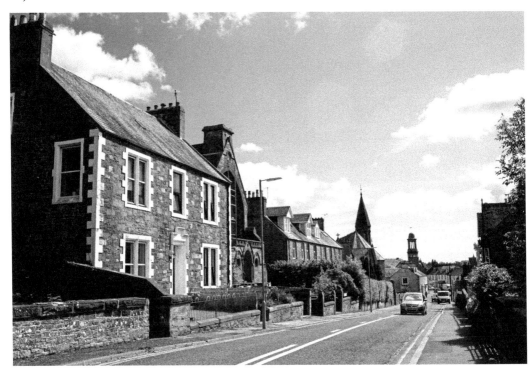

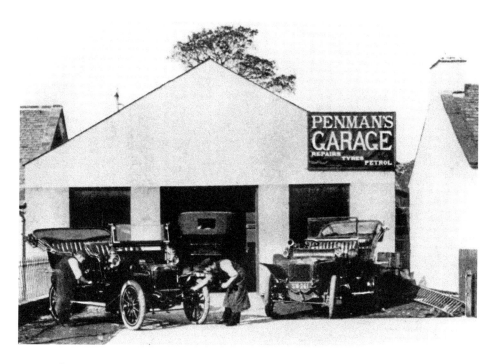

Penman's, Cotton Street

In 1866, Penman's Garage was established in Castle Douglas. Penman's son, A. C. Penman, formed his own company in Dumfries. The photograph is from 1920, probably shortly before the firms amalgamated, becoming A. C. Penman Ltd. Robertson Gemini was originally established in Dalbeattie in 1921 by William Robertson. The family business grew and expanded and in 1993 Robertson's moved into Castle Douglas. It continues to be a family business and Gemini was added to represent the twin boys who will be the fourth generation.

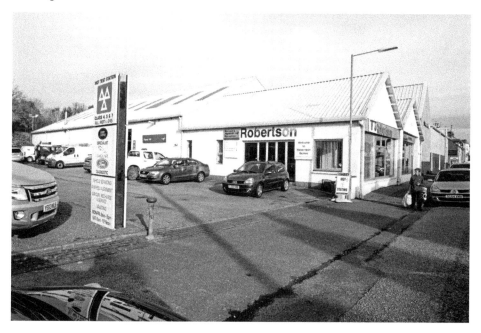

J. & R. Wallace, Cotton Street

Established in 1876, the foundry, as it was always called, continued for over a hundred years. James and Robert Wallace were millwrights, building and repairing water mills, and also produced agricultural machinery. The firm developed a pulsating milking machine and invented an automatic water drinker for cattle. Its manure distributor, pictured in the advert, was a huge commercial success. After the foundry closed, the Co-op bought the site. It later moved further down Cotton Street and the foundry site is now occupied by Wilko.

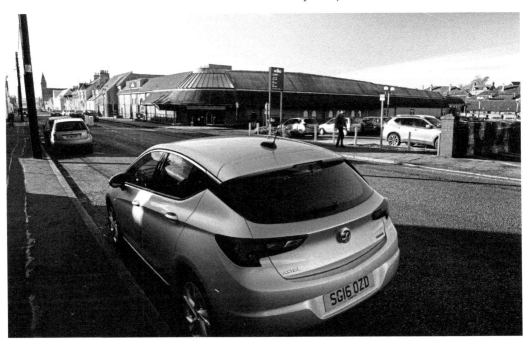

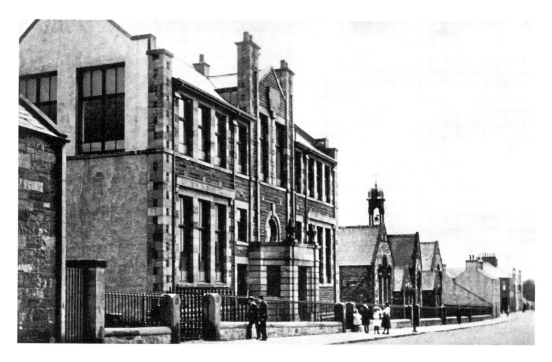

Community Centre, Cotton Street

This sandstone building began life in 1910 as Kelton School Board – Higher Grade School. Later, it became Castle Douglas High School. It is now used for community activities and is home to a busy IT centre and a day centre for older people. The building next door was built in 1872 when compulsory education was introduced and simply called B School. When the new primary school was built, it became St John's Roman Catholic Primary School. Now it is used for community activities.

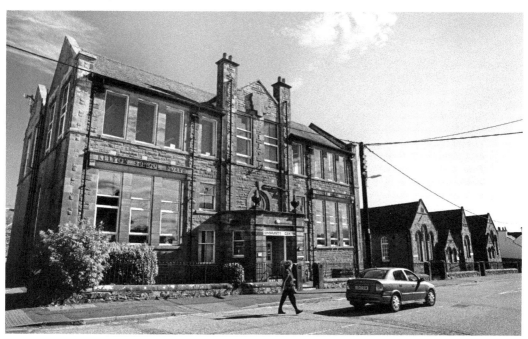

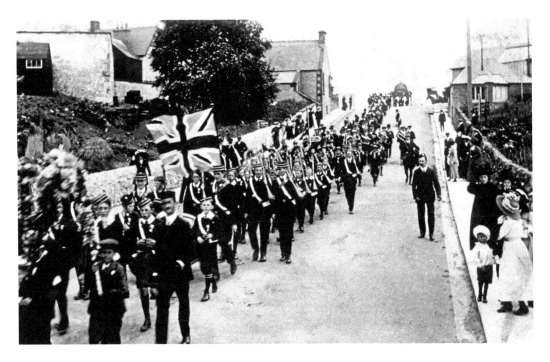

Cotton Street

The parade to celebrate the coronation of George V is marching down what locally is known as 'the slaughterhouse brae' after the abattoir, which was at the bottom of the hill. It has gone now, as has Mr Littlejohn's Patent Lemonade, Ginger Beer, Soda Water and Selzer Water Manufactory, which operated on steam power, filling almost 800 bottles an hour. This too was the street on which William Douglas began his short-lived cotton factory.

The Galloway News

The first issue of the *Kirkcudbrightshire Advertiser*, which later became *The Galloway News*, was on 30 July 1858. It cost a penny halfpenny. It now costs £1. Founded by John Stodart, on his death his business partner John Hunter Maxwell took over. The printworks on King Street also printed periodicals and books. It closed in 1972. Some years later, the office relocated to the Station Yard then to share offices with sister paper *The Standard* in Dumfries.

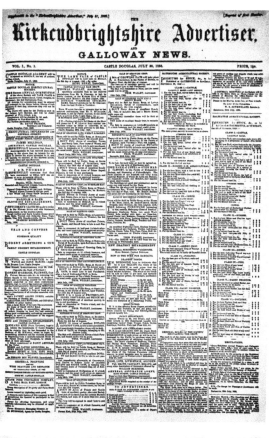

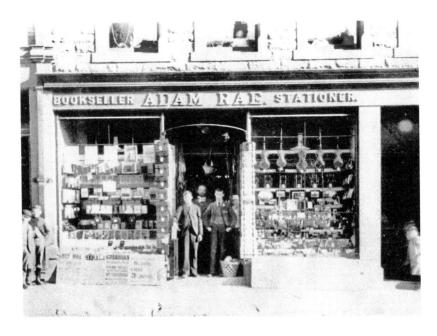

Adam Rae, King Street

Adam Rae, pictured at the back, was a well-known figure in the town. He established his stationery and bookselling business in 1888. He was also Provost of Castle Douglas from 1910 to 1912. His son, Adam, took over the business on the death of his father in 1912. Since this photo was taken, the building has undergone several changes and is now Enigma gift shop.

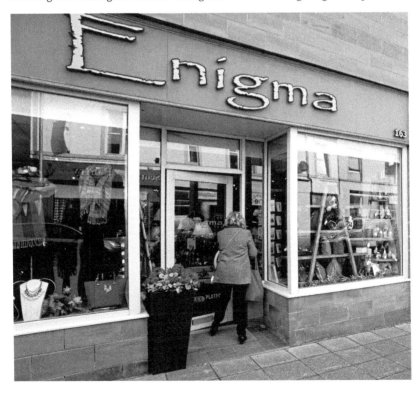

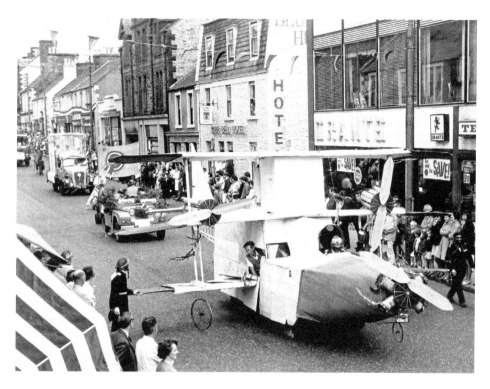

King Street, Douglas Day Parade

The amazing aeroplane has 'flown' past the Blue Bell Hotel, formerly the Ram Inn, now Marchmont Bakery, and is alongside Grants, which was a furniture shop. The next shop was Templeton's. Some of the vintage tractors in the present-day photo would have been very modern when the old photo was taken in the early 1960s.

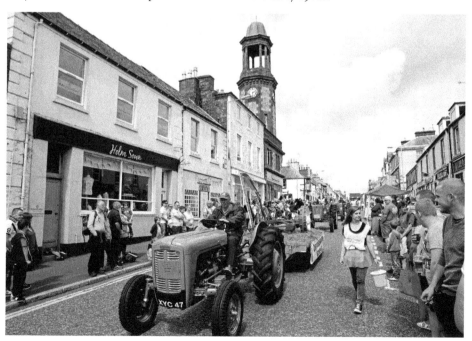

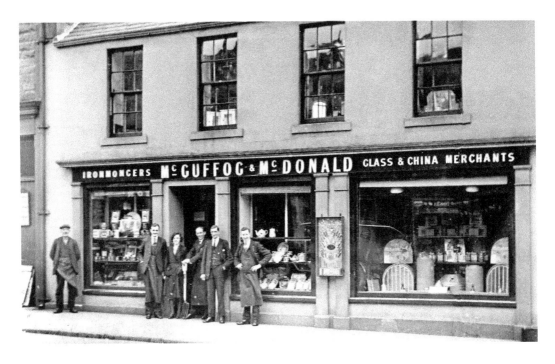

McGuffog & McDonald, King Street

This part of King Street has changed greatly over the years with several buildings pulled down. The ironmongery, which also sold china and glassware, was in the gap that leads into residential King's Court. The store extended a long way back and had a huge range of stock. Next door, on the extreme left of the photo, was Adam Rae's shop.

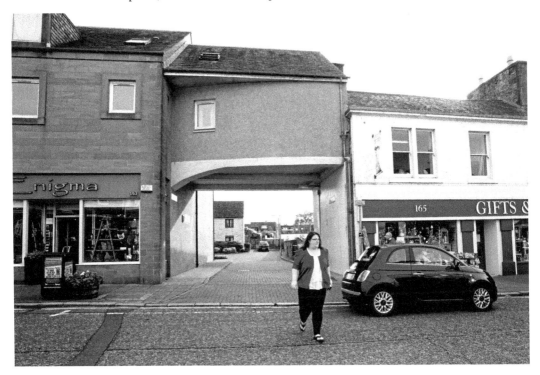

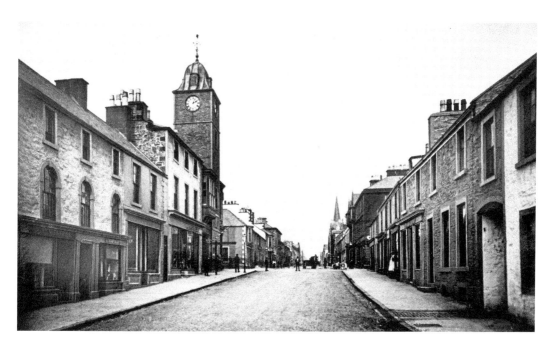

King Street Looking North

Immediately below the clock tower – the second to burn down – a striped pole indicates a barber's shop – George McCann, Hairdresser. The premises are now occupied by Clience Studio Gallery. The property next to Holm Sewn was the Rendezvous Café. It has remained empty and in a deteriorating condition for many years. A mural painted on the façade prevents the building from being an eyesore.

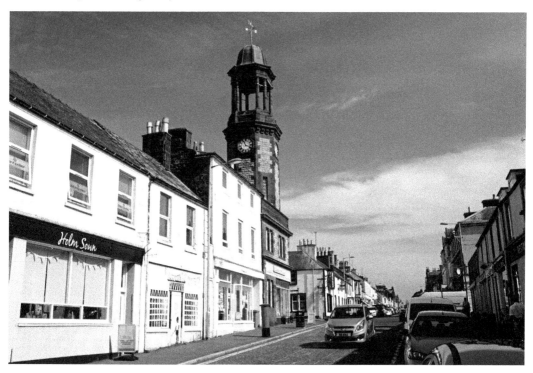

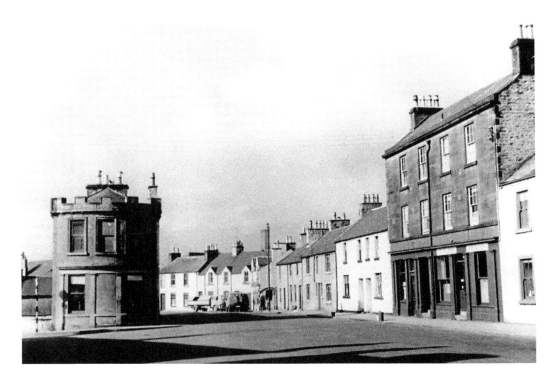

Barbeth Castle, King Street

This bow-fronted, battlemented building was sometimes referred to as the 'round house'. The great-grandmother of Elaine Kirk, who provided the image, lived here and Elaine's grandmother was born here and her uncle, John Douglas, lived here until 1957. It had three doors, water was from an outside tap and the toilet was behind the garden across the road. It was demolished around 1960 and Brown's Filling Station occupied the site, which in turn has given way to a charity shop. On the right was McElroy's printers, Brown's garage and the old fire station.

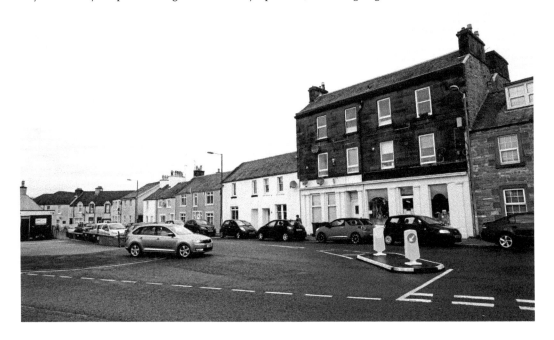

Acknowledgements

A great many people have supported us in putting together *Castle Douglas Through Time* and we are truly grateful to them all. A big thank you goes to retired newsagent Drew Low, who provided many of the images in the book. His grandfather, who started the family business in 1900, also published postcards – The Galloway Series – several of which we have used. Drew has an encyclopaedic knowledge of Castle Douglas shops and accompanied me and my notebook up and down King Street providing a history lesson.

Keith Kirk loaned us a folder packed full of information about the town's history, John Nelson provided the wonderful image of a touring car pulling a hay turner and our friend from *Dumfries Through Time* days, John Kerr, turned up trumps at the last minute with a postcard of Market Crescent, an image we had not seen before. Robin Hogg has been very supportive and, following an appeal in the local paper, Mr Beck from Annan sent us some postcards. Elaine Kerr provided the photo of the amazing Barbeth Castle where her great-grandmother lived and thanks to her uncle, John Douglas, for his memories of living there.

Thanks go to Jon Gibbs-Smith for IT support and to freelance editor Lynn Watt who checked for my inevitable typos – I think she may have found fewer commas this time round. Thanks also to the many people – too many to name – who shared memories, recalled names of people and have shown such great interest in this project.

Our thanks to Joanne Turner, museums officer of Dumfries Museum and Camera Obscura, and her counterpart, Anne Ramsbottom at the Stewartry Museum, who both provided some wonderful images from their respective collections.

Credits for images from the Dumfries Museum and Camera Obscura: pp. 10, 14, 18, 32, 35, 39, 41, 51, 52, 61, 66, 78, 85.

Credits for images from the Stewartry Museum: pp. 7, 8, 9, 12, 13, 17, 20, 22, 30, 34, 54, 58, 59, 65, 68,76.

Credits for images from the Ewart Library local history collection: pp. 31, 37, 38, 49, 50, 90.

Bibliography

Gibson, Jean, *Foot Forward in Castle Douglas* (Castle Douglas: Barry Smart, 1976)

Gibson, Jean, *Round About Castle Douglas* (Castle Douglas: Barry Smart, 1976)

Gordon, Haig, *The Kirkcudbrightshire Companion* (Kirkcudbright: Galloway Publishing, 2008)

Harper, Malcolm, *Rambles in Galloway* (Dalbeattie: Thomas Fraser, 1896)

Maxwell, J. H., *Maxwell's Guide Book To The Stewartry of Kirkcudbright* (Castle Douglas: J. H. Maxwell, 1908)

Penman, Alistair, *Old Castle Douglas* (Catrine, Ayrshire: Stenlake Publishing, 1998)

Westwood, Peter, *A Pictorial History and Reminiscences of Castle Douglas from 1792* (Dumfries: Creedon Publications, 2014)

About the Authors

Author, poet and journalist Mary Smith lives in Dumfries and Galloway. Her novel *No More Mulberries* and her memoir *Drunk Chickens and Burnt Macaroni* have both come out of the ten years she spent working in Pakistan and Afghanistan. Her poetry has appeared in a wide range of publications and her first full-length collection is *Thousands Pass Here Every Day*. She and Allan have collaborated over the years on many magazine articles. This is their second publication for Amberley as they worked together on *Dumfries Through Time*.

Also based in Dumfries and Galloway, Allan Devlin is a freelance photographer and journalist. He concentrates mainly on southern Scotland and while capturing its varied landscapes and culture, he has developed a strong love of the area, which can clearly be seen in his photography. As well as undertaking commissioned work, Allan has also written for magazines such as *The Great Outdoors*, *Outdoor Photography* and currently writes a monthly article for *Dumfries & Galloway Life*, all based on walking or being out of doors in southern Scotland.